Light and Shade in Watercolour

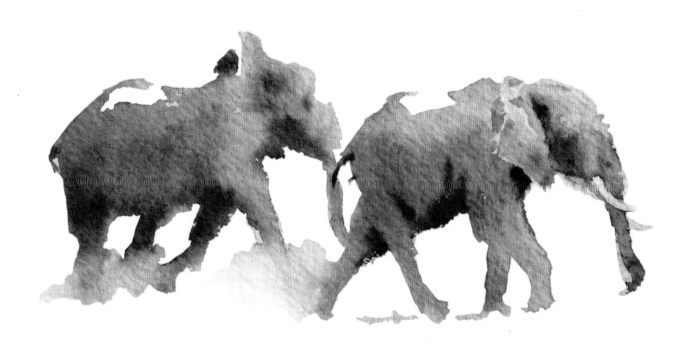

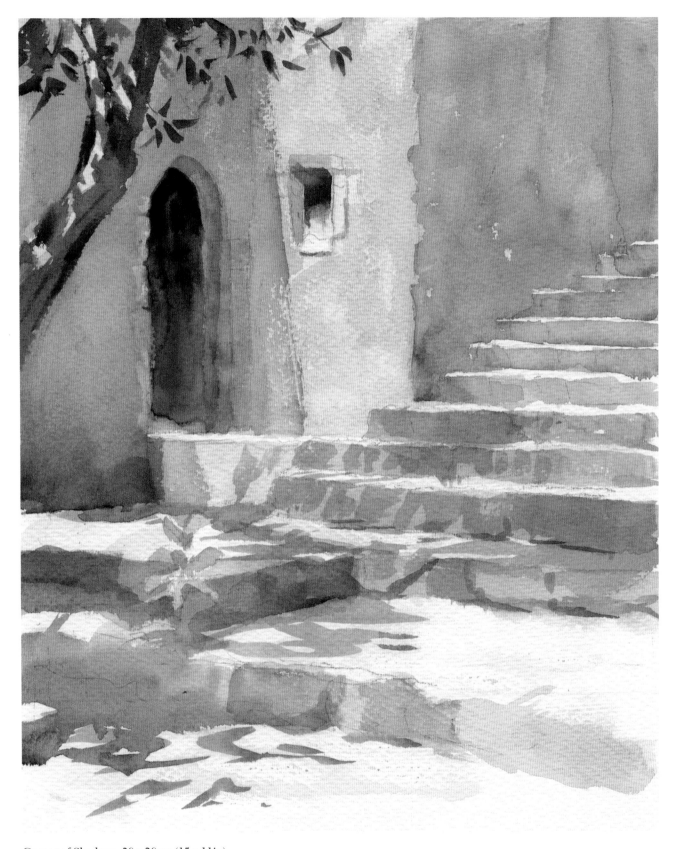

Corner of Shadows, 38 x 28cm (15 x 11in)

Light and Shade in Watercolour

Hazel Soan

BATSFORD

Dedication:
To the many people who bring light into my life.

Acknowledgements:
Thank you to Cathy Gosling and my wonderful publishers for believing in my ideas; to Kristy Richardson,
my editor, for making the passage to print so smooth; to Tokiko Morishima for her splendid design; to my
family for their support and to my readers for making it all worthwhile.

First published in the United Kingdom in 2019 by
Batsford
43 Great Ormond Street
London WC1N 3HZ
An imprint of Pavilion Books Company Ltd

Copyright © Batsford, 2019
Text and images © Hazel Soan, 2019

ISBN: 9781849945264

A CIP catalogue record for this book is available from the British Library.

25 24 23 22 21 20 19
10 9 8 7 6 5 4 3 2 1

Reproduction by Mission Productions, Hong Kong
Printed and bound by 1010 Printing International Ltd, China

This book can be ordered direct from the publisher at the website www.pavilionbooks.com,
or try your local bookshop.

Distributed in the United States and Canada by
Sterling Publishing Co. Inc., 1166 Avenue of the Americas,
17th Floor, New York, NY 10036

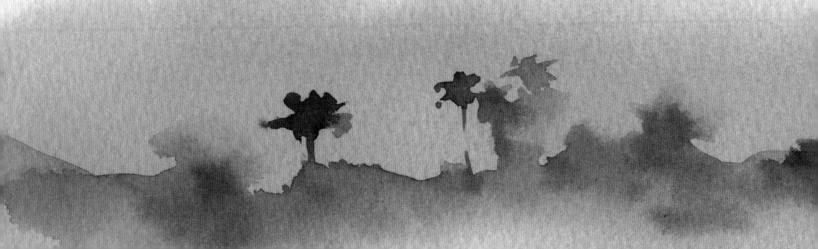

Contents

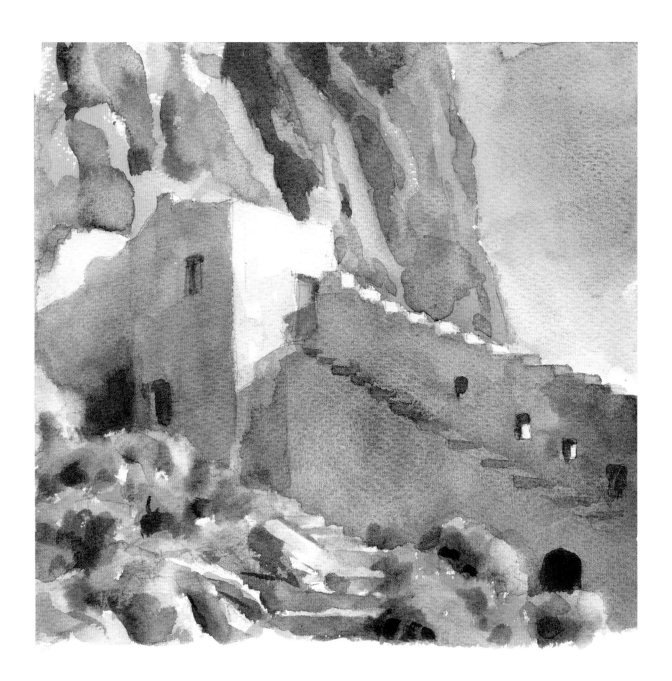

'Adrift in the Aegean', Ramparts, Monemvasia, 30 x 28cm (12 x 11in)

Introduction

It's all about light and shade

With the light from white paper reflected back through transparent, see-through films of paint, watercolour is ideally suited to convey light and shade and create paintings full of illumination.

Light is the main character in this book, but without its twin – shade – we cannot show the light, nor paint the form. It is shade that makes the light visible and thus, in painting, light and shade link to become one – and a whole language that painters use to turn patterns and shapes on a flat surface into evocative representations of the three-dimensional world.

The Significance of Light and Shade

Art critics often praise artists for 'painting the light', but in watercolour painting, where white paper represents the light, the artist can only make light appear by painting the shade. The chief challenge of watercolour painting is therefore not to 'paint' the light but to 'retain' the light. A watercolour is created by covering enough of the paper with brushmarks to suggest the visible world, but not so much as to lose the light reflected back from the paper through the translucent films of paint.

To make light visible you must paint the shade.

Listening in the Stillness, 25 x 30cm (10 x 12in)
The light in this watercolour is represented by the patches of unpainted paper and lightly tinted areas.

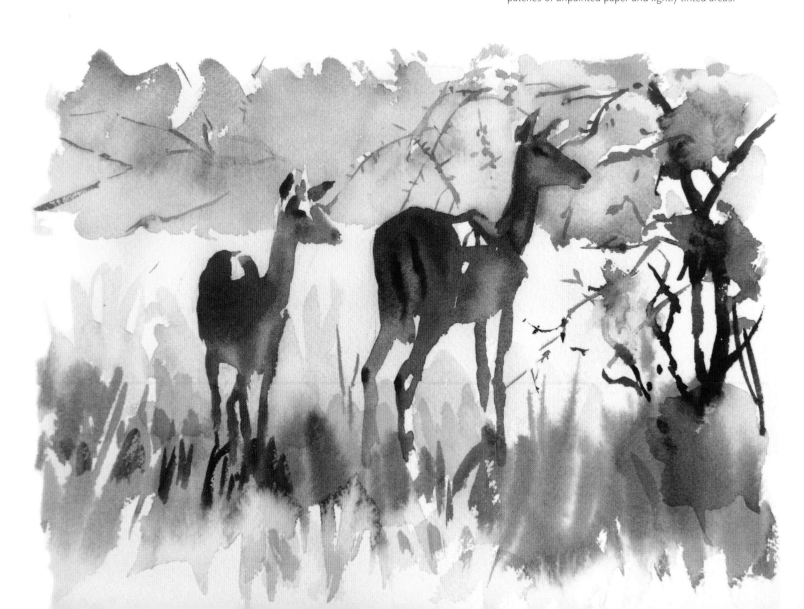

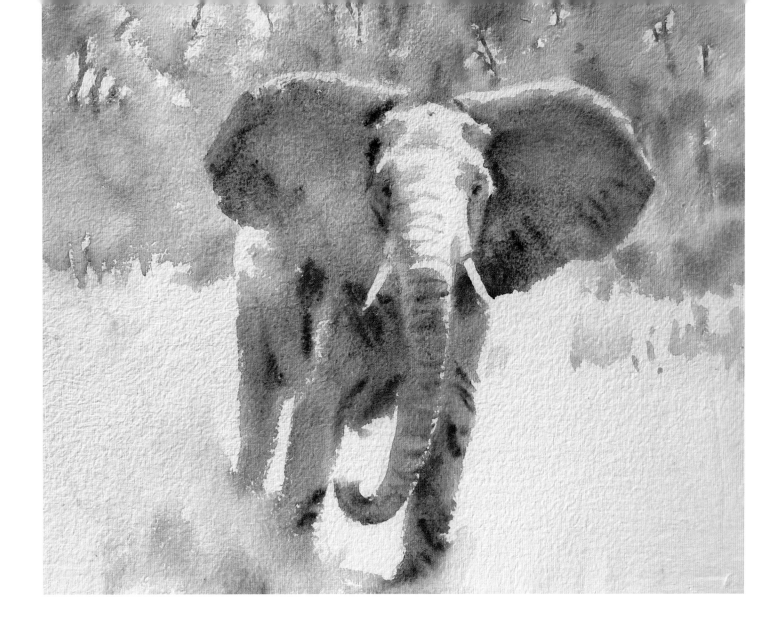

The Language of Light and Shade

'Light and shade' in painting refers to more than the difference observed between sunlight and shadow – it is about every tonal relationship between things, whatever the light source or intensity. To see your way across a room or down a parade of steps, your eyes perceive subtle differences in tone to discern depth and distance; so too in watercolour. Light and shade are inseparable, referred to by the collective terms, 'tone' and 'value'. These terms describe the quality of a colour, or hue, as modified by degrees of light and shade. The terms are interchangeable, and sometimes linked as 'tonal value'.

Close Encounter
56 x 71cm (22 x 28in)
This painting exhibits an obvious balance between light and shade, weighted in almost equal proportions between the light of the white paper, the mid-tone background area, and the deeper shade of the approaching elephant.

This Book

Creating a watercolour follows a journey that starts with the eyes, filters through the mind, the heart, the gut and the soul, carries along the arm to the hand, into the brush and onto the palette, ferries to the paper and then returns back to the eyes. The chapters in this book trace a similar route, following the train of thought into practice, establishing first how to see the tonal values exhibited by light and shade, then how to assess and value them, and finally how to respond by turning their pattern into meaningful paintings.

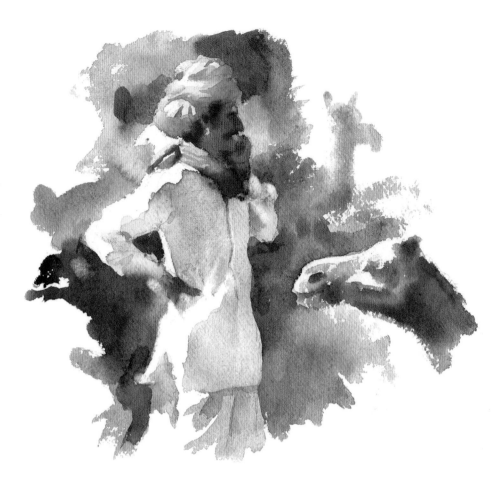

Sketch of a camel trader,
25 x 20cm (10 x 8in)
Sketchbooks are made for watercolour observations. Here, the light and shade playing over the surface of the white tunic and the saffron turban begins the process of assessing whether a colour should be painted lighter or darker than the adjacent feature or background.

Guides for the Journey

Practical research assignments act as guides on the journey to increase your expertise. Confidence is key: if it does go wrong (and it probably will), remember it is only paper – expensive paper but only paper – and, for better or for worse, the best way to learn to paint in watercolour is to cover lots of paper!

Encouraging words and mottos run through my head while I am painting (many are scribbled on my studio walls) so I offer some of these among the pages and whisper the occasional 'aside' to provoke thoughts while painting or boost your confidence. The penultimate chapter offers tips on finding and representing the message of 'light and shade' residing within specific subjects, such as figures, wildlife and architecture. Of course, by then you may not need them ... Enjoy the journey – it is an exciting one!

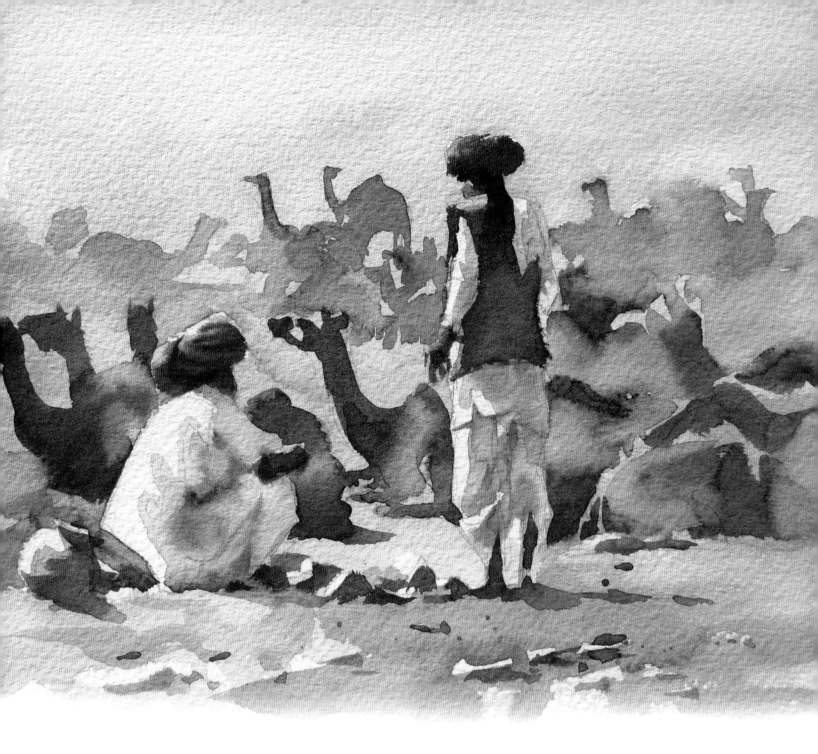

Pushkar Camel Fair,
25 x 28cm (10 x 11in)
I made several watercolours and many
sketches at the Pushkar Camel Fair in India
before I felt I had rendered the atmosphere
successfully in this one. Familiarity with the
subject emboldened a looser rendition.

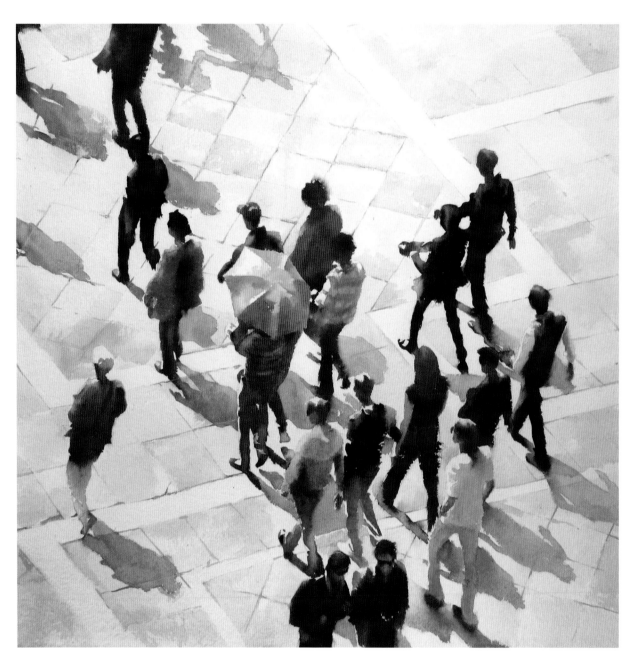

Standing Out From the Crowd, *76 x 76cm (30 x 30in)*

First You Have To See

How to see the values of light and shade through an artist's eyes

Light makes things visible, and only with light can matter be seen and observed. The different wavelengths of visible light are represented in the colours of the spectrum, and, depending on the wavelengths absorbed and reflected by the matter around us, together with the amount and intensity of the light received, we perceive a whole range of colours and shades. As light and shade swap places during the rotation of the Earth, the change in angle and direction of the light determines that the colours of everything 'under the sun' are subject to constant variation. No colour or shade is therefore absolute.

Colour is Double-edged

Colour is made up of hue and tone (or value). Hue refers to the name of the colour – yellow, orange, red, blue, etc. Tone/value is the lightness or darkness of the colour as it is modified by light or the lack of it.

Because colours change according to the amount of light they receive, they are therefore inseparable from their value, which means the word 'colour' is really a composite word including both hue and tone.

To mix a specific colour for a painting the artist has to assess both the type of hue and the value of the tone. Lit colours are referred to as 'tints', and shaded colours as 'shades'. A few hues have common names for their tints and shades, other hues use the prefixes 'pale' and 'dark'.

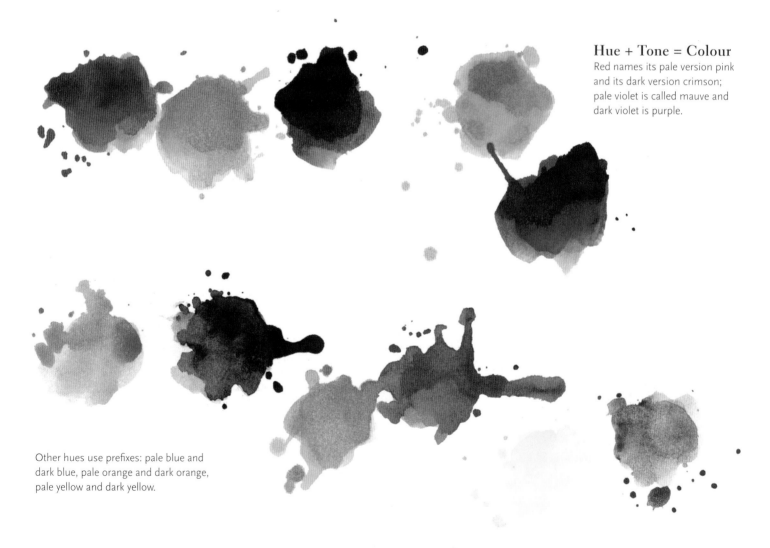

Hue + Tone = Colour
Red names its pale version pink and its dark version crimson; pale violet is called mauve and dark violet is purple.

Other hues use prefixes: pale blue and dark blue, pale orange and dark orange, pale yellow and dark yellow.

Depth Perception

The eye evaluates patterns of light and shade in order to perceive forms and judge distance. So too in painting – the light and shade of the colours becomes the code by which we can represent three-dimensional forms and suggest space on the two-dimensional surface of the picture plane. If representation is the intent, tone is more important than hue in the colour equation. Gauging tonal values is therefore crucial to the success of representational painting and carries greater significance than matching hues.

The art of seeing is the ability to judge/assess the tonal value of a hue in order to mix the correct colour for the painting.

Venice Rising,
28 x 38cm (11 x 15in)
This virtually monochromatic view of Venice shows how clearly tonal values can suggests space and distance in a painting. Indigo is diluted to a pale hue for the distant buildings and used neat and dark in the foreground features.

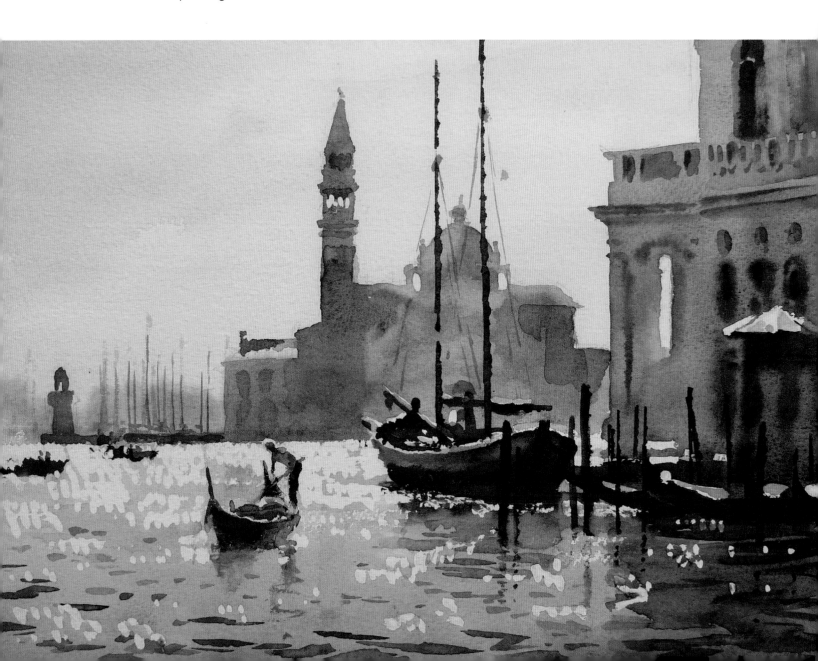

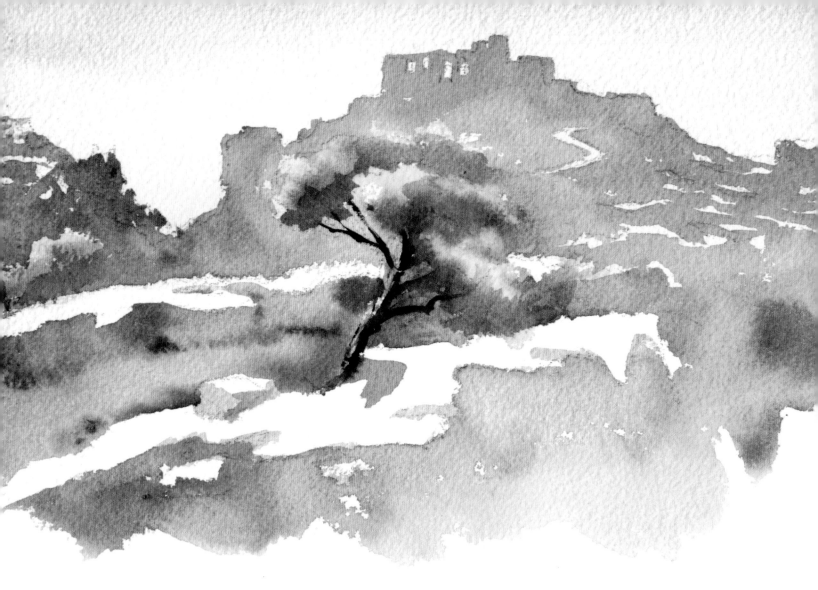

Convincing Lies

Representational painting is really a deception, an illusion of space and depth within the bounds of a small flat surface. This collusion is fashioned by patterns of light and shade. The abstract pattern made by the play of light and shadow over the subject is the key to projecting the illusion, and therefore the key to making a successful painting. Instead of seeing individual physical items as separate features, the artist looks for the tonal values that link things together to make the pattern, using the light and shade which transcends the physical boundaries. A practical example could be a shadow cast from a tree with a person sitting in the shade beside it, these two items are no longer separate elements but combine to become one shape in the painting.

Les Beaux, *18 x 28cm (7 x 11in)*
Think of light and shade as a code, shared with the viewer, so they can interpret the colourful patterns on the paper as places and things from the physical world. Within a few simple washes here, a rocky landscape, a pine tree, a distant castle and a winding road are readily decoded.

Seeking Shade

There are two kinds of shade that impact painting: the shadow on the side of an object or form where it is turned away from the light source, and a cast shadow, which is produced by an obstruction of the light source. Although shadows are areas of reduced light they rarely come in black – the colour that represents the absence of light – but are modified by light reflected from objects in the vicinity or exhibit colouring opposite to the colour of the light source.

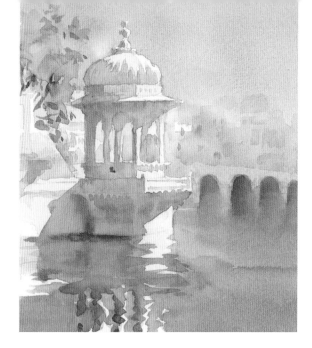

Seeking Shade, *30 x 40cm (12 x 16in)*
Nearly all the springbok are standing in the cast shade from the acacia tree; only the rump of the antelope immediately to the left of the tree trunk exhibits shade caused by a facet turned away from a direct light source. The tree foliage is also subject to shade from direct light.

Truly Indian Yellow, Udaipur, India, *28 x 25cm (11 x 10in)*
The shadow on the side where the temple pergola is turned away from the morning sun is not as dark in tone as the cast shadow below the walking platform.

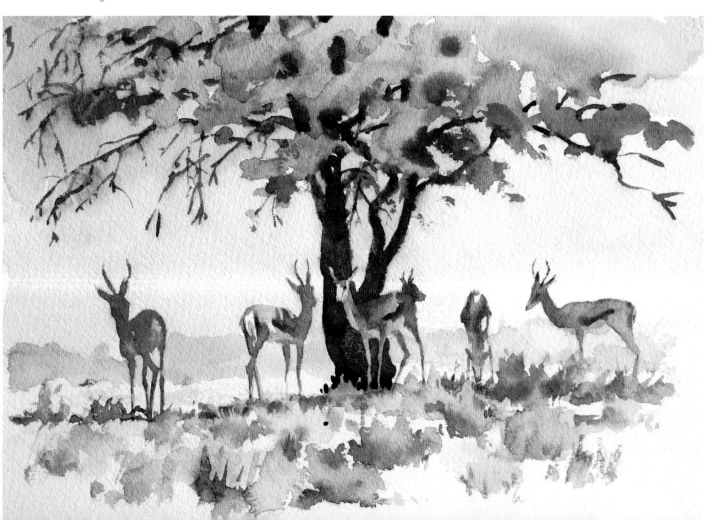

The Source of Light

As the Earth turns, shadows move, so you always need to be aware
of the direction of the light source, and how the angle will alter as the
day progresses. Awareness of the direction and angle of light is vital in
establishing credible values in the painting. Projecting how shadows will
shift during a *plein-air* painting session is obviously critical to the timeframe
available for completing a composition. The more you observe and paint
from life the more instinctive your response will become, especially if you
paint in different hemispheres! Astonishingly, many people are unaware
even of the direction in which the Earth is turning – not so painters.

Small Corner in the Adriatic,
Afternoon, Symi, Greece,
28 x 38cm (11 x 15in)

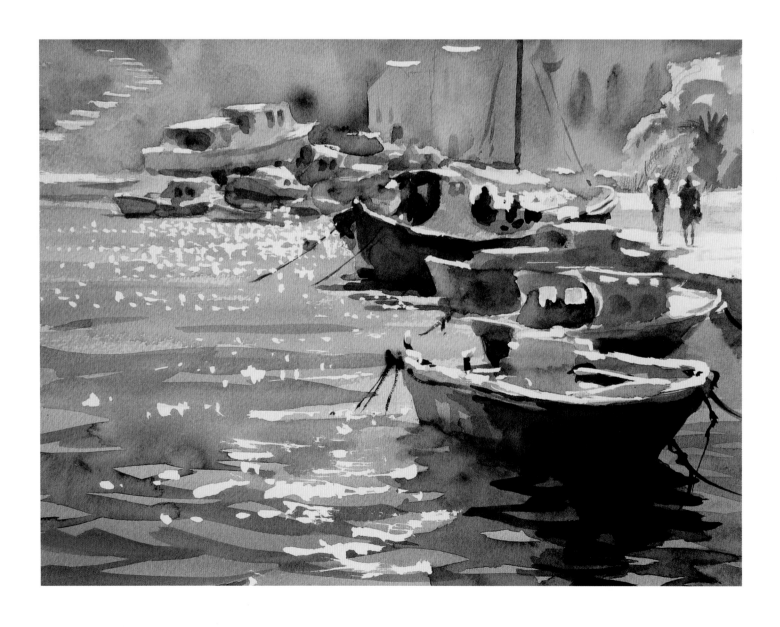

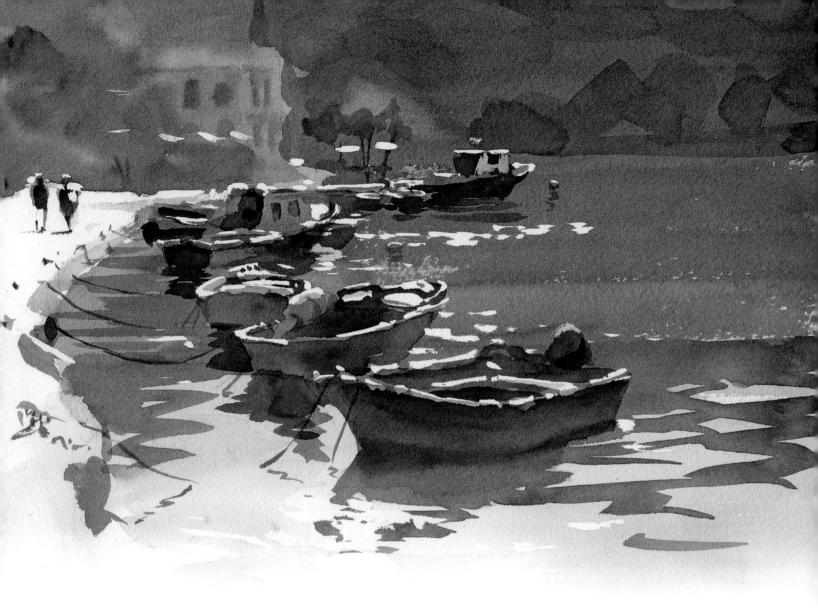

Looking to the Light, Morning,
Symi, Greece, 28 x 38cm (11 x 15in)

The Strength of Light

I enjoy the dramatic tonal contrast of *contre jour* ('against the daylight') painting. The two watercolours here were painted in the same harbour, both looking towards the light, one in the morning, the other in the late afternoon, and therefore each is painted from opposite ends of the quay.

The intensity of the light defines the level of contrast between the lit features and those in shadow. Direct sunlight creates strong contrasts, so the range between the light and dark tones is wide. Overcast light softens tonal contrast, creating subtle values within a narrower range. Artificial light offers a constant light source, useful for portrait and still-life painting. Multiple light sources make for exciting, complex and often confusing patterns of lights and shadows so the key to judging tonal values here is to recognize the predominant light source.

Angles of Light

The angle of the light source affects everything and is often the catalyst for inspiration.
It determines the overall pattern of light and shade and is the bedrock of composition.

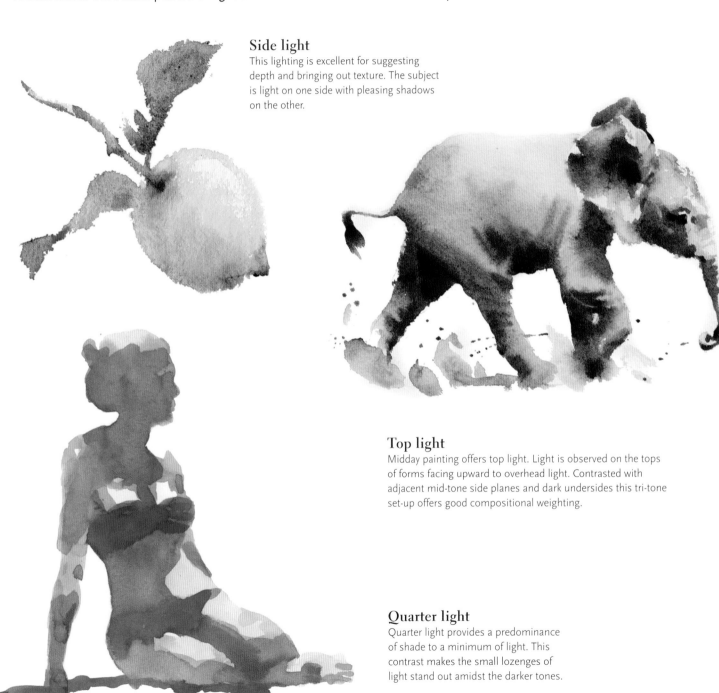

Side light
This lighting is excellent for suggesting
depth and bringing out texture. The subject
is light on one side with pleasing shadows
on the other.

Top light
Midday painting offers top light. Light is observed on the tops
of forms facing upward to overhead light. Contrasted with
adjacent mid-tone side planes and dark undersides this tri-tone
set-up offers good compositional weighting.

Quarter light
Quarter light provides a predominance
of shade to a minimum of light. This
contrast makes the small lozenges of
light stand out amidst the darker tones.

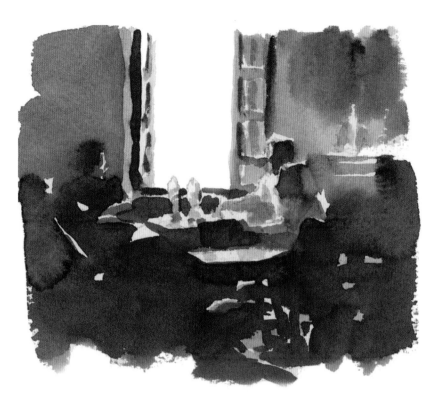

Back light

Known as *contre jour* ('against the daylight'), back light throws features into silhouette. Light is made more obvious by contrast, so the more darkness, the more the slivers and halos of light take effect.

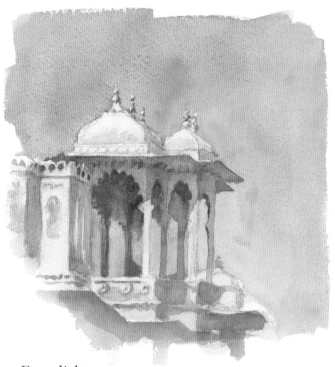

Front light

There is not much shade to use for modelling forms when lighting is fully from the front so it is the least 'useful' angle for a watercolourist. The projecting eaves supply the shade needed here to show form.

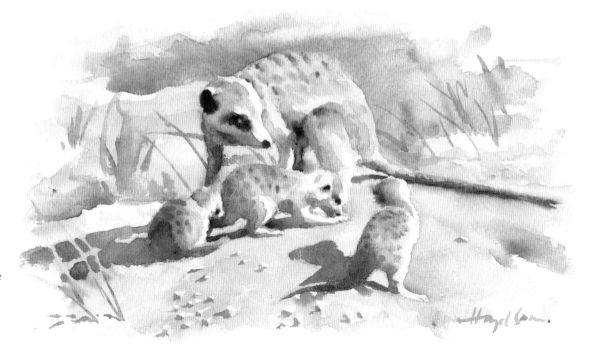

Three-quarter light

A three-quarter light offers a greater ratio of lighted area to shaded area. The subject is well lit from the front but with enough shade cast around the far side to indicate form. This angle allows for light, bright colourful paintings in which local colour predominates.

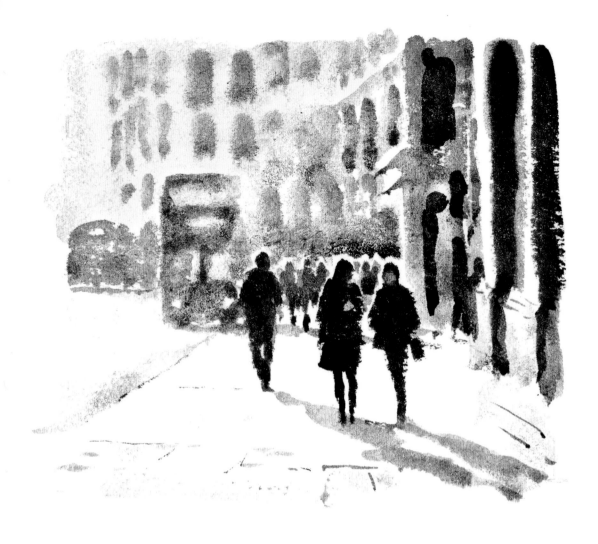

West End,
15 x 15cm (6 x 6in)
Sketching in a monochrome range from pale greys to black is a good way to learn to see and evaluate tonal values as you do not have to concern yourself with colour.

A Full Range of Tones

To establish the range of tones in your subject, find the lightest light and then the darkest dark; the tones of all the other features will lie in between. It is a good idea to practise this assessment by continual observation, valuing the tones in any view or subject in relation to a light/dark scale.

Values Can Be Deceptive

It can be difficult to determine the nuances of light, dark and mid-tones playing across a chosen view, especially as you notice more variation the longer you look. Local and adjacent contrasts often distract the eye from the whole, and reflected light may trick the eye into forgetting an area is actually in shadow. Squinting with half-closed eyes is a great help in evaluating tone: by removing distracting detail it is easier to see the overriding values – the main pattern of light and shade.

Feline, 56 x 76cm (22 x 30in)
I followed the nuances of light and shade playing over the lioness rather than worrying too much about local colour, so that any of the colours I chose to include in the painting could be employed to establish the tonal pattern, with warm colours favouring the top sides and cooler colours favouring the paler, whiter underside.

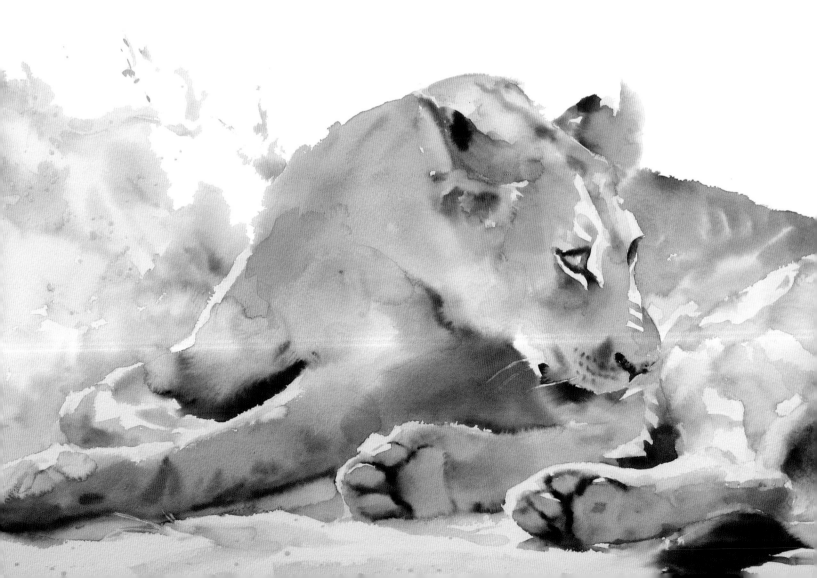

Light and Shade by Design

Composing a watercolour requires some planning simply because the white paper represents the light and a thoughtless wash or brushstroke quickly denies the painting its source of light. Planning can be done in your head or on paper. In landscape painting a small preparatory tonal sketch *before* you start painting will save a lot of time – and paper. By noting the light source and the main tonal values in relation to each other and the whole you can quickly see if the tonal composition has strength for a painting.

A drawing for a watercolour is intended as a guide for the brush, telling it where it can and cannot go – where it is safe for paint to flow freely, where it should be brought to an abrupt halt or leisurely disperse in a watery blend. Therefore, draw out your composition with reference to the pattern of light and shade rather than the physical items, using pencil marks to demarcate where changes in tone occur. Valuable painting time is often lost on sketched details that are quickly obscured by a dark wash. You can always draw over dried paint later if you need more information.

If there is time light-wise, it is a good idea to make a small preparatory tonal sketch of the main values operating within the subject before starting a painting.

Corridor of Light, *61 x 43cm (24 x 17in)*
Composition is forged by a patchwork of light and shadow, links and separations – a guiding pencil sketch enabled me to reserve the small highlights on the figures, direct the shadows and align the tiling.

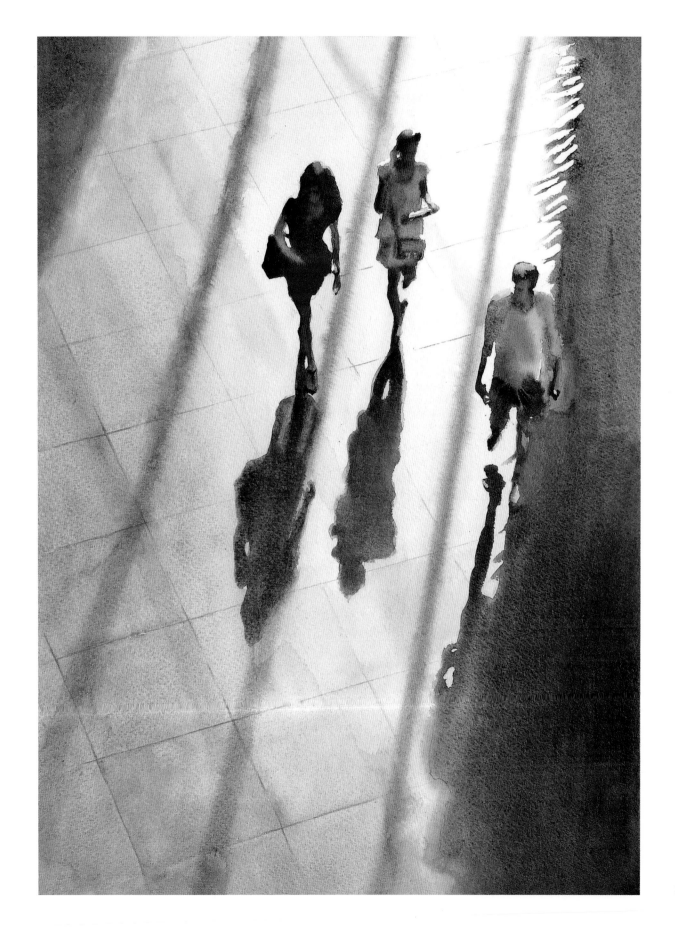

Tone is relative:
an observation workout for the eyes

DISCOVER

- Tone is relative.

- Tonal values are exciting to observe and paint.

- Everything is an interesting subject to paint if it has a play of light and shadow.

Stage 1: Understanding relative tone

Seat yourself in front of a window bar or balcony rail, backed by a background displaying alternate areas of light and shadow, such as trees and sky. Move your head up and down and from side to side so that the bar/rail is backed first by a dark tone and then by a lighter tone. Observe how the bar/rail appears to change tone according to the background – it appears darker in relation to the lighter background and lighter against the darker background. The light on the bar has not changed but its relationship with the background has. This is what is meant by relative tone and is the information you need for a painting.

Stage 2: Using tone to show form

Let's get painting then! Find some white or pale coloured items with definite three-dimensional form; I chose some white marble statues and columns. Use just two colours (here I used a blue and a yellow, Cobalt Blue and Yellow Ochre) and make a tonal painting, leaving the lightest areas as white paper. Note the changes of tone on either side of your pencil lines and try to match their relationship. Don't worry about making a whole painting at this stage, just observe the relative tonal values where your lines demarcate a change of plane.

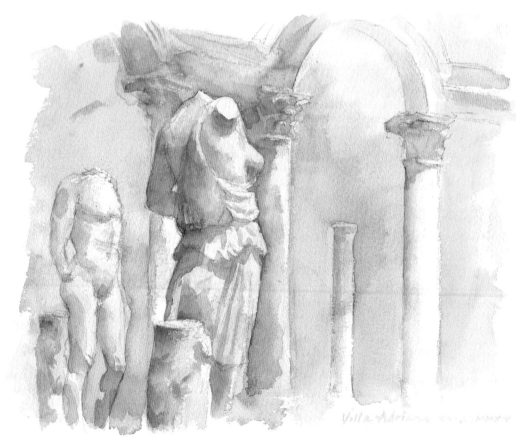

Villa Adriana, Italy,
28 x 38cm (11 x 15in)

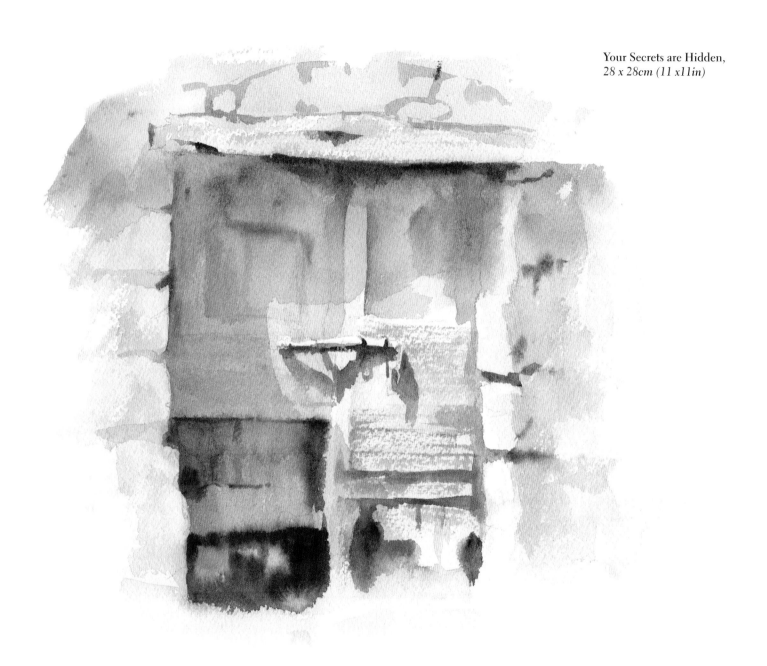

Stage 3: Trying something harder

Next find an object that is virtually flat, such as a door or window, and sit directly in front of it so there is no perspective. The door is on the same plane as the wall, so to set it back we need an exchange of tone to occur on our paper. Hint at the texture on the door only after you have set it into the wall; form first, surface detail after.

'Use the subject to paint a watercolour, not watercolour to paint the subject.'

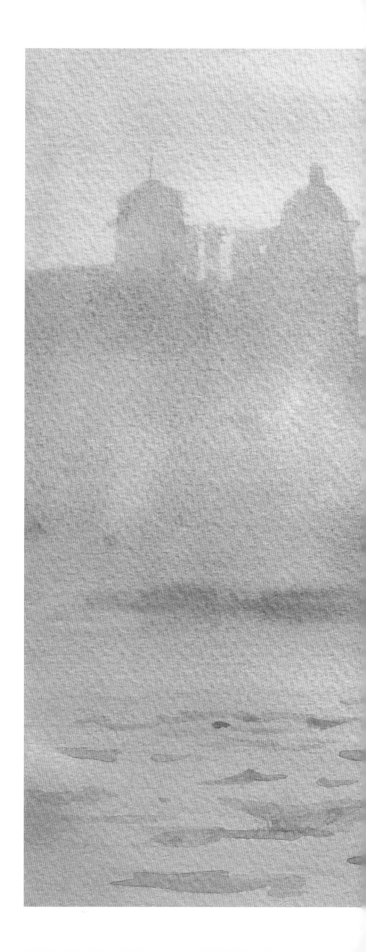

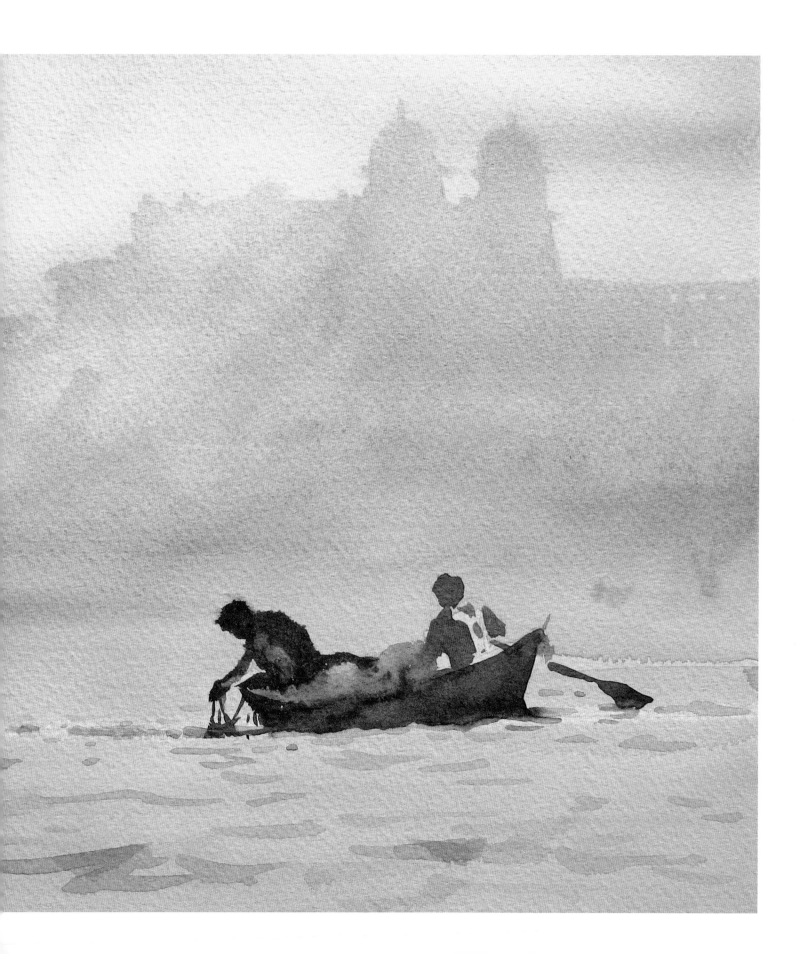

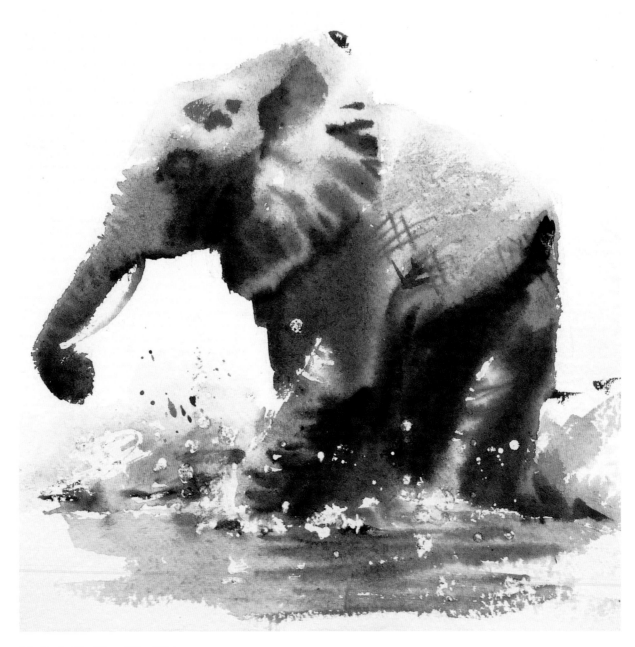

Mudbath, *30 x 30cm (12 x 12in)*

Then You Can Paint

Why the medium of watercolour is adept at representing light and shade

The attractive appearance and unique illumination of watercolour comes from the light bouncing off the white paper, through and between pigment particles, like light shining through stained glass. The greatest transparency is therefore found in the initial layers, which is why watercolour welcomes quick rendition and benefits from the maxim 'less is more'.

Watercolour requires few materials. These are light to carry, quick to set up, and the water for mixing and rinsing is normally readily available. Consequently watercolour is ideal for painting *en plein air*, and at a moment's notice. These attributes make it the perfect medium for capturing the fleeting effects of light and shade created by changing light.

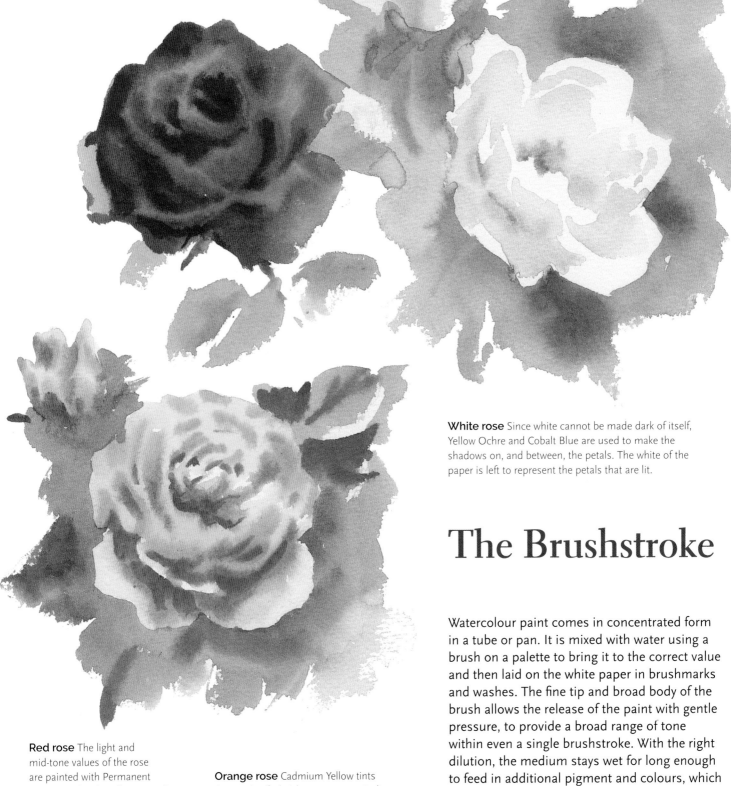

White rose Since white cannot be made dark of itself, Yellow Ochre and Cobalt Blue are used to make the shadows on, and between, the petals. The white of the paper is left to represent the petals that are lit.

The Brushstroke

Watercolour paint comes in concentrated form in a tube or pan. It is mixed with water using a brush on a palette to bring it to the correct value and then laid on the white paper in brushmarks and washes. The fine tip and broad body of the brush allows the release of the paint with gentle pressure, to provide a broad range of tone within even a single brushstroke. With the right dilution, the medium stays wet for long enough to feed in additional pigment and colours, which further enable and enhance tonal variation. The brushmarks and washes are therefore full of inherent tonal variation, facilitating attractive transitions between light and shade.

Red rose The light and mid-tone values of the rose are painted with Permanent Rose mixed with Cadmium Red, but the inherently darker nature of Alizarin Crimson is then needed to deepen the red for the shadows.

Orange rose Cadmium Yellow tints the petals of a bright orange rose, Indian Yellow meets the mid-tones, and the addition of Cadmium Red makes the orange that represents the glowing hue in deep shadow.

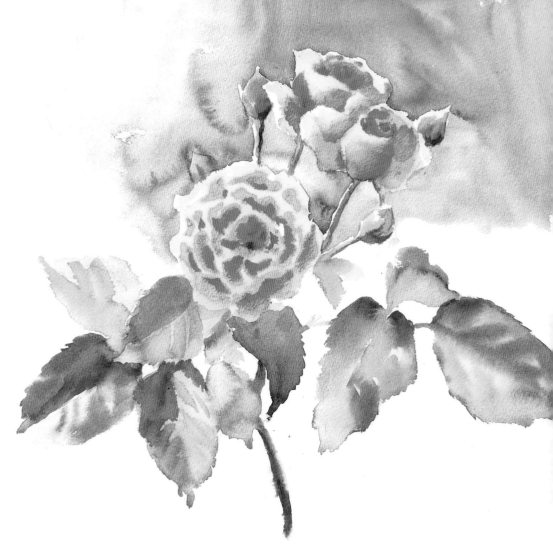

Using opposite colours for surrounding foliage can enhance the brightness of a flower's hue but it is better to deepen the flower's own depths with a colour closely related in hue because mixing opposite colours tends to dull the bloom.

Range of Tone Within Colour

Colours change according to the amount of light they receive and are inseparable from their value. Watercolour is well-equipped to handle this broad range of tone from pale to dark because concentrated colour is so easily diluted. The neat watercolour in the pan shows the hue in its deepest form and therefore demonstrates the potential range of tone available through dilution. Colours that look dark or deep in the pan provide a wide range of values from deep shades to pale tints, whereas the paler hues (such as most yellows and mid to light opaque colours) offer a narrower range and can only be deepened with the addition of another colour.

Yellow rose A rose may be labelled yellow in colour, but in order to paint its form, several different values of yellow are needed, ranging from the palest lemon yellow for petals fully lit to a deep orange, or even a brown like raw umber, in the shadows.

The White Paper

The untouched white paper offers the brightest light in watercolour and is used to represent the highlights. Such is the nature of a contrast that, even though watercolour paper is traditionally a creamy white, it can appear as dazzling light in the midst of passages of painted shade. Since the source of light is the white paper, transparency is at its greatest in the first and early layers. Films of transparent hues are overlaid to create new colours and shades, but too much layering, especially with the less transparent pigments, eventually dulls and blocks the light as the particles of pigment overlap and fill the gaps through which light bounces back.

Passage of Linear Time, Tunisia, *18 x 28cm (7 x 11in)*
The colours of the dark passage, Raw and Burnt Umber and Prussian Blue, are laid wet-into-wet in a single layered wash to maintain their transparency. The watercolour came together with the few additional brushstrokes.

The First Wash is the Freshest

Watercolours are traditionally built from light to dark but this does not mean that deep and dark values cannot be laid at the outset to ensure a layer of maximum transparency. The nature of watercolour is 'less is more': the freshest watercolours are made with a succinct number of brushstrokes and colours. Not only does the limited palette make for more colourfulness, it also enables you to concentrate on the all-important tonal relationships instead of worrying about matching individual hues.

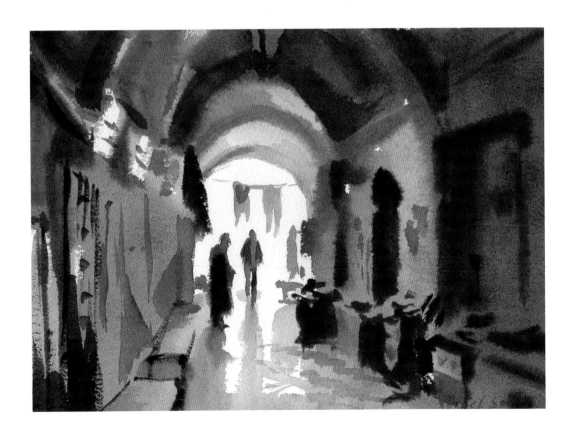

Mary at the Window, Lady in Waiting, *35 x 25cm (14 x 10in)*
The untouched paper is so effective at showing light in a watercolour that even a creamy white watercolour paper amply displays the dazzle of bright light.

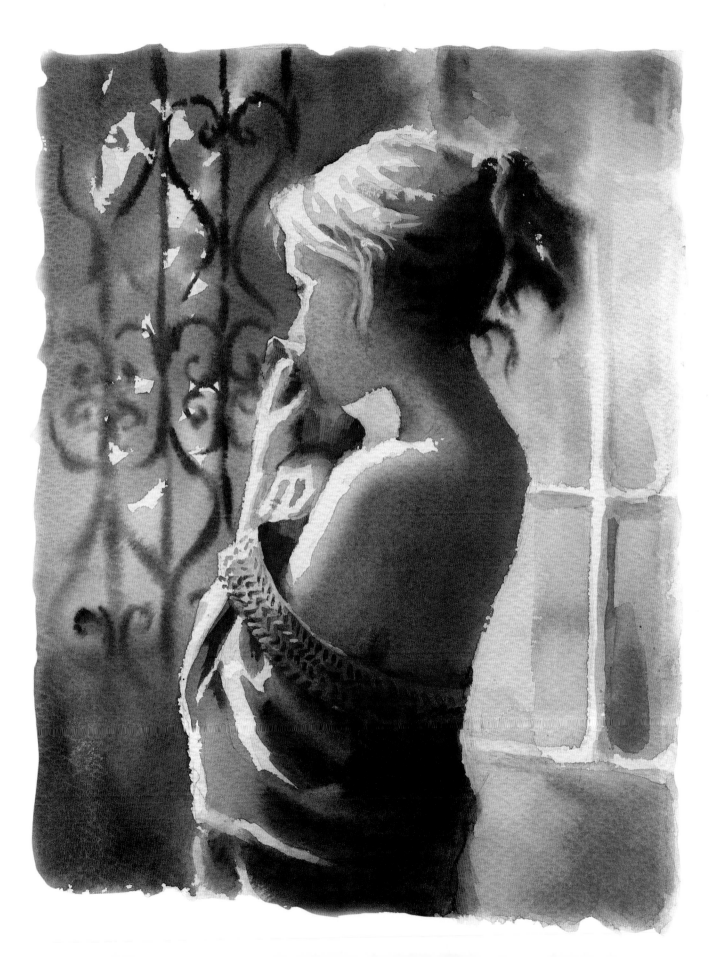

Light to dark values

Draw a square grid. Leave the top left square as white paper and paint the bottom right-hand square in black. Choose a range of hues from your palette and mix each individually: start with the most intense version you can make and then dilute with water, incrementally, to make the fullest range of tones possible. With a flat brush, fill in the squares diagonally across the grid, upwards from right to left, darkest to lightest tone, guessing roughly where you think a neat colour might come in the range. Mix lighter hues with a deeper colour to make darker versions. Aim to grade the tones from lighter to darker across the grid, both diagonally, and from top to bottom and side to side, but do not worry if it becomes irregular.

DISCOVER

- Explore the range available within each hue and get to know what your colours can offer. Have fun!

- You can check your tonal range by photographing or photocopying the grid in black and white.

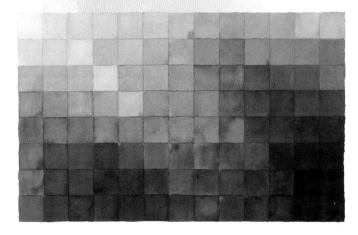

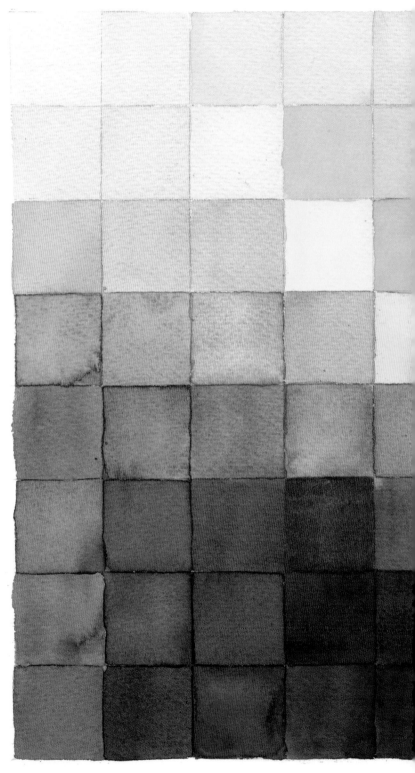

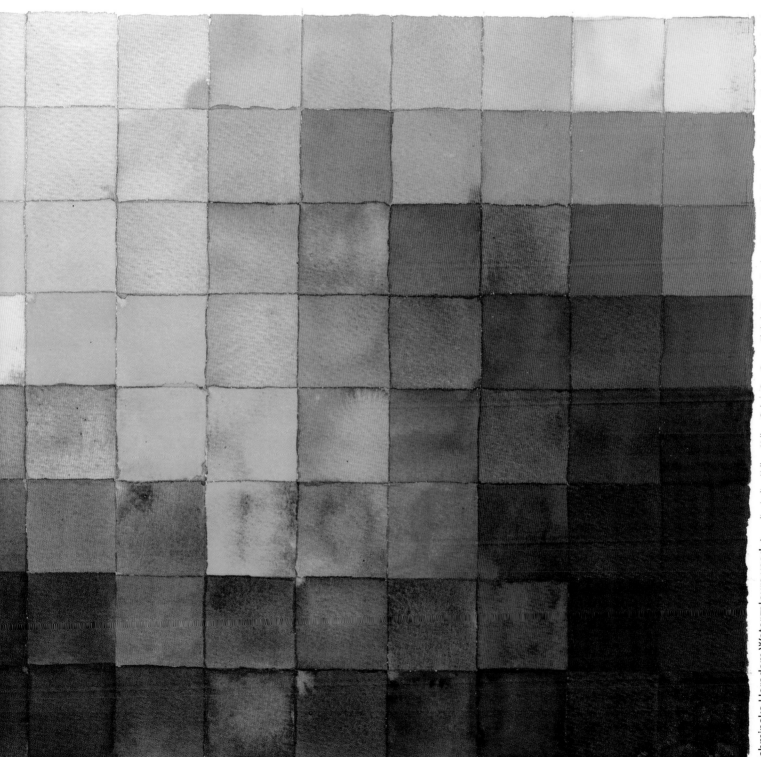

Schmincke Horadam Watercolours used: Aureolin, Indian Yellow, Yellow Ochre, Sap Green, Phthalo Green, Perylene Green, Helio Cerulean, Indanthrene Blue, Bright Red Violet, Violet, Phthalo Blue, Prussian Blue, Ultramarine Blue, Permanent Rose, Cadmium Red, Alizarin Crimson, Transparent Orange, Burnt Sienna, Madder Brown, Raw Umber, Burnt Umber, Sepia.

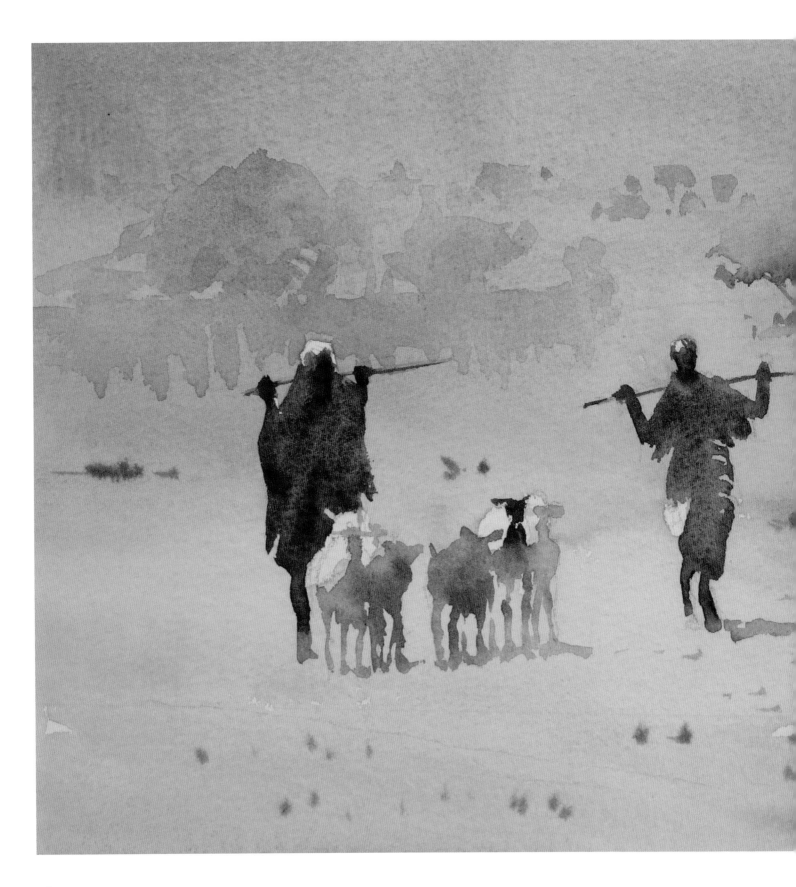

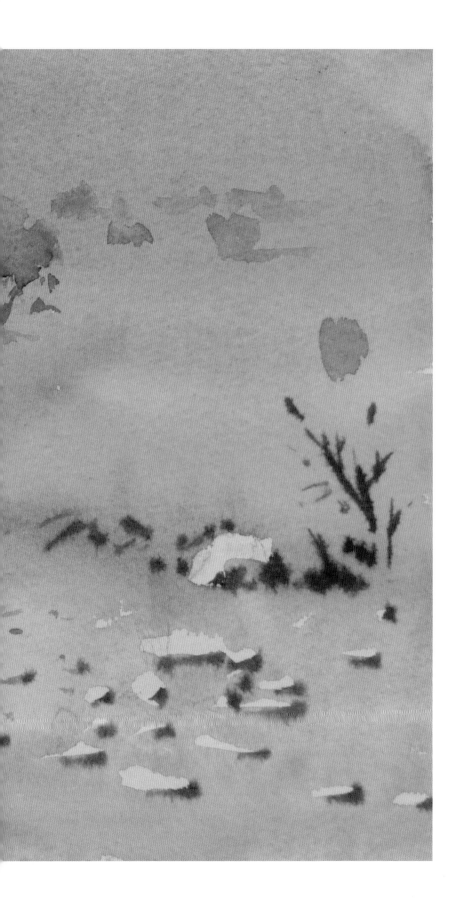

'Don't tidy
it up too
much – the
life is in the
brushstroke.'

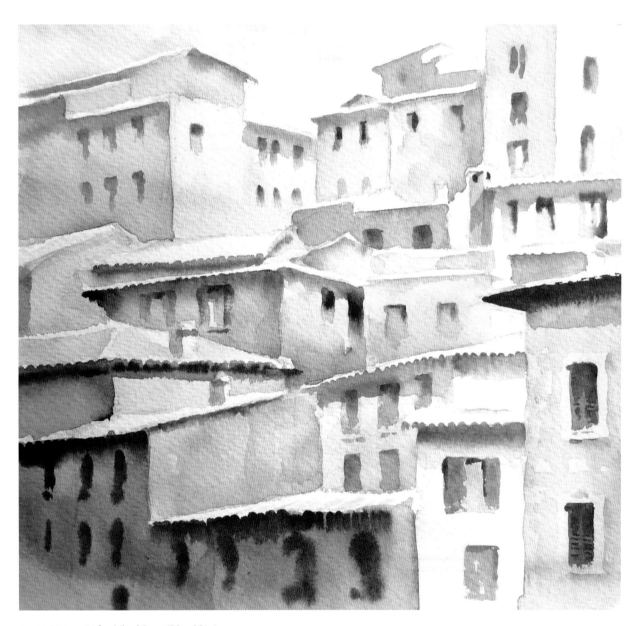

Assisi Rising, Italy, 25 x 28cm (10 x 11in)

Tame the Abstract Pattern

Balancing the light and shade through compositional design

Paintings are flat mosaics comprising lines, shapes and colours.
A watercolour is a pattern of light and shade before it is a representation
of its subject matter. See the patterns of light and shade as the means to paint
the watercolour, rather than watercolour as a means to paint the subject. In
this way, you will respond to the design needs of the painting rather than try
to imitate the view in front of you. The task of the painter is not to copy the
world but to create something new. Planning a composition is about taking
into account what a painting requires to succeed. Make a painting,
not an imitation: you are a creator, and your artistic licence
comes pre-approved!

Patterns of Light and Shadow

Strong watercolours are built on a foundation of solid design. The design is called the composition, and its strength will depend on your ability to see the subject in terms of its shapes, colours and values. If background and setting are integral to the painting, the chances are you will need to draw out a design before starting the painting. The aim of composition is more than just the positioning of the features in balanced relationship within the boundaries of the painting, it also takes into account the pattern of light and dark shapes playing across the subject. Taming this abstract pattern is the art of composition.

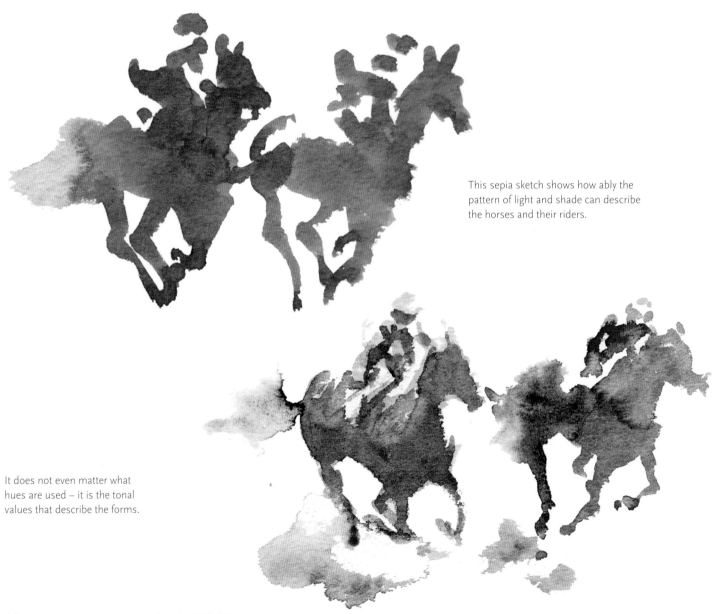

This sepia sketch shows how ably the pattern of light and shade can describe the horses and their riders.

It does not even matter what hues are used – it is the tonal values that describe the forms.

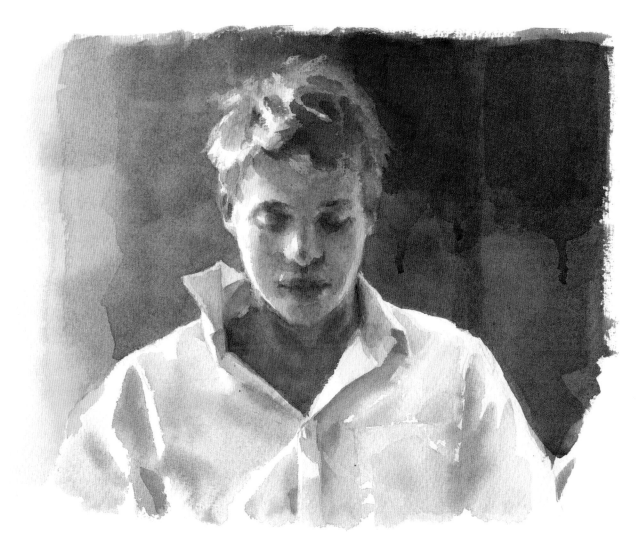

Under the Sun

Whether a watercolour is made in a short time or over a longer period, the pattern of light and shade must be consistent to be convincing. *En plein air*, it is a good idea to separate morning and afternoon painting sessions to avoid lit sides being exchanged for shadows as the sun passes its zenith. The light and shadow viewed at the start is most likely the pattern that inspires you, so avoid chasing shadows as they shift. I prefer the patterns created by direct sunlight and shadow but an advantage of overcast skies is the prolonged uniform light. Photographic reference is useful in that it freezes the pattern of light and shade, (albeit into a small world), but there is a danger of slavery to a static view in which a changing tonal scenario cannot be imagined. Painting is not imitation; it benefits from the elements of change that foster generalization and your decisions are easier to make if the light and shade (or any element) is subject to change in front of you. This is why it is definitely beneficial to learn to paint directly from life.

Sean in a Rumpled Shirt,
25 x 30cm (10 x 12in)
The shirt represented in this portrait is undoubtedly white in colour but to paint it convincingly I must portray the pattern of light and shade, leaving the lit folds as untouched white paper and painting the shaded parts with blue and yellow.

Three Tones = Three-dimensional Form

With three main tones – light, dark and mid-tone – three-dimensional form and space can be readily indicated on the picture plane. Light, dark and mid-tone grading around an object fashions the illusion of form; a recession of the three main tones – from strong and bright, through mid-tone, to pale – gives the illusion of space and depth and suggests distance.

In watercolour, once the lightest light, darkest dark and mid-tones are established, the grading of intermediary values can be delegated to the diffusion that comes naturally with this medium. In oils and acrylics, the painter must use fastidious methods of blending to accomplish gradual tonal transition; in watercolour a gradual, or radical, grading of tone is achieved by the diffusion of the pigment particles as they disperse in the wet washes and brushstrokes.

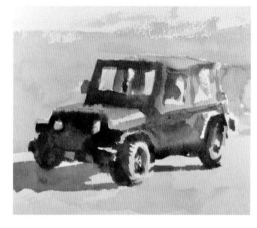

Jeep, *18 x 28cm (7 x 11in)*
The boxy shape of the little jeep is shown by a lighter tone on the roof, a mid-tone on the side and a dark tone underneath.

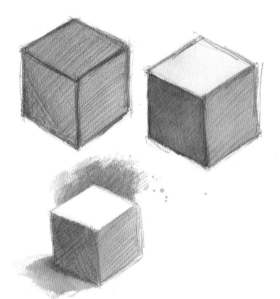

Create three-dimensional form
The top left hexagon here uses perspective to turn itself into a cube, but the top right has found a more convincing way to suggest three dimensions: each side is painted with a gradual increase in tone – light, mid, dark. Factor in the background and shadow added to the lower cube, enabling the top surface to be left unpainted, and the 3-D form is even more persuasive.

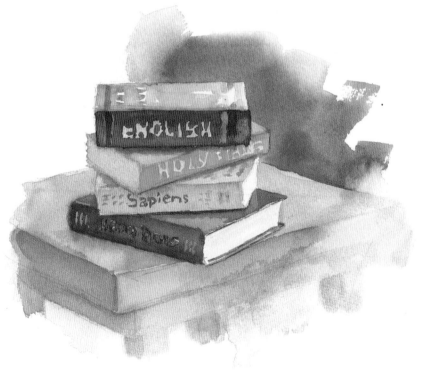

Value tone
With dark covers and pale pages, and each book at a different angle to the light, the relative tones playing over this pile of books were quite confusing to assess. By noting the three likely main tones – lit upperside plane, mid-tone right-side plane, dark left-side plane – I could paint them with consistency.

Geometrize forms

These rocks are rounded forms, essentially irregular polyhedrons. All objects fit into boxes, so the three main tones, light, medium and dark, can still be used to describe the essential planes. Transitional tones are used to show the curved nature of surfaces. The difference between the strong lights and darks of the rocks and the paleness of the hills suggests space and distance.

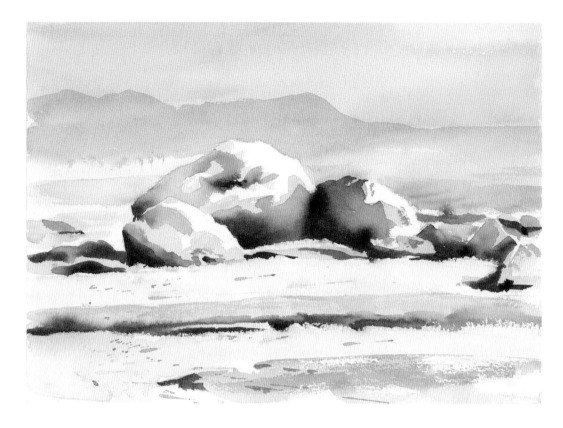

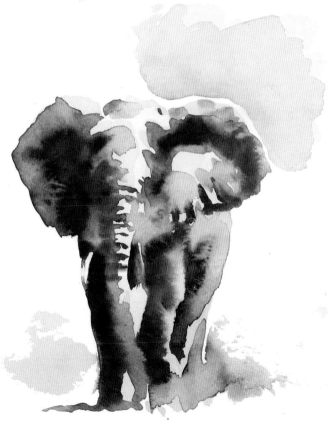

Let watercolour 'paint' the transitions

An elephant is a very irregular form but he still exhibits three main tones (though we do not wish to put him in a box!). Lit from top right, he is darkest on the opposite side. The mid- to dark tone areas were wetted and then deep, intense violet paint was brushed in; the pigment particles floated out into the damp area and effectively 'painted' the transitional mid-tones for me.

Linking Similar Tone

Similarity of tone links areas together, particularly in the shadows. Separation occurs more frequently in the light. To establish the general pattern of light and shade, rather than viewing the subject as a grouping of isolated features, look for links of compatible tone. On the flat surface of the painting the separate items of the physical world become an intricate weave of lights and shades linked with the background. (If you ever practiced 'painting by numbers' as a child you will recognize this as the formula behind those puzzling designs.)

Get the values right and the colours look after themselves.

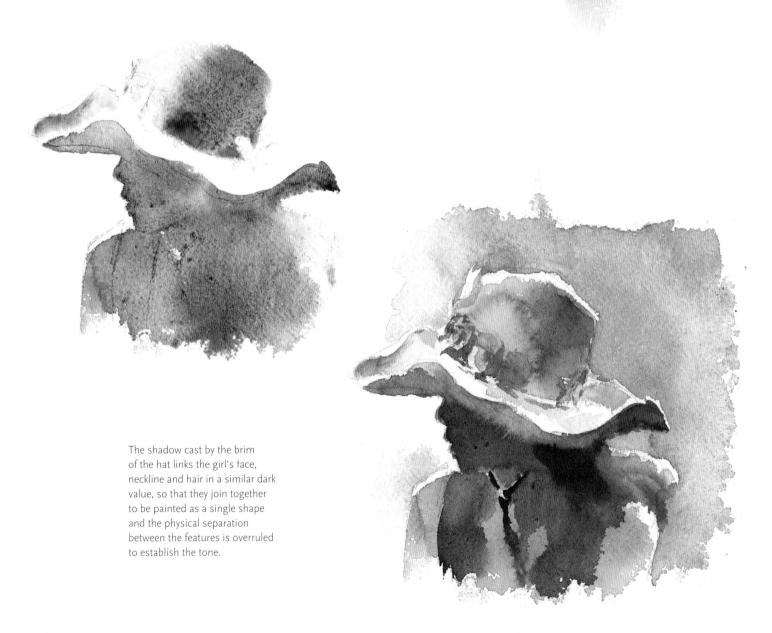

The shadow cast by the brim of the hat links the girl's face, neckline and hair in a similar dark value, so that they join together to be painted as a single shape and the physical separation between the features is overruled to establish the tone.

Cast Shadows

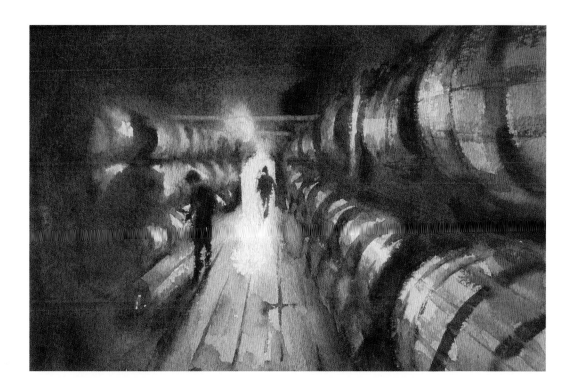

A cast shadow cannot exist without the object that casts it, so shadows are inextricably linked to their owners. In the composition, the shadow is a continuation of the shaded side of an object and may even link with other shadows to become one large, extended shape. Shadows vary in depth of tone along their length and may be subject to reflected or infiltrated light.

A proximity shadow is a shadow created between items where they meet and touch, as shown below. It is deepest at the point of touch and often linear. Proximity shadows are useful for describing the position of things in relation to other things and make a good place to forge links or provide a breathing space between washes.

The side of an object casting a shadow and the shadow itself are joined at the hip – here it is literally the toes! The man and his shadow are inextricably linked so all the dark tone is painted at once as if it were one item.

Ageing in Secret, Buffalo Trace, Kentucky, USA,
18 x 28cm (7 x 11in)
Proximity shadows link surfaces that meet and touch. Here in the dim light of the distillery warehouse, the bottom of one barrel is linked to the top of the other by a deep proximity shadow.

Definition and Ambiguity

Colour and value benefit from contrast, and so does design. In a watercolour, an area of defined edges and strong contrasting values can be balanced elsewhere by an area of blurred or indistinct edges and harmonious values. The focus of the painting will determine the part or parts with the most detail; definition is generally shown in the light and ambiguity in the shade. Since extreme light bleaches out detail, most description is found in the mid-tone area between light and shadow.

Poised to Pounce,
56 x 76cm (22 x 30in)
By alternating between definition for some of the spots and grass blades, and the blurring of others, an impression of movement is bestowed. On the left the cheetah is painted with a darker tone than the white paper background; on the right the background is painted in a darker tone than the cheetah.

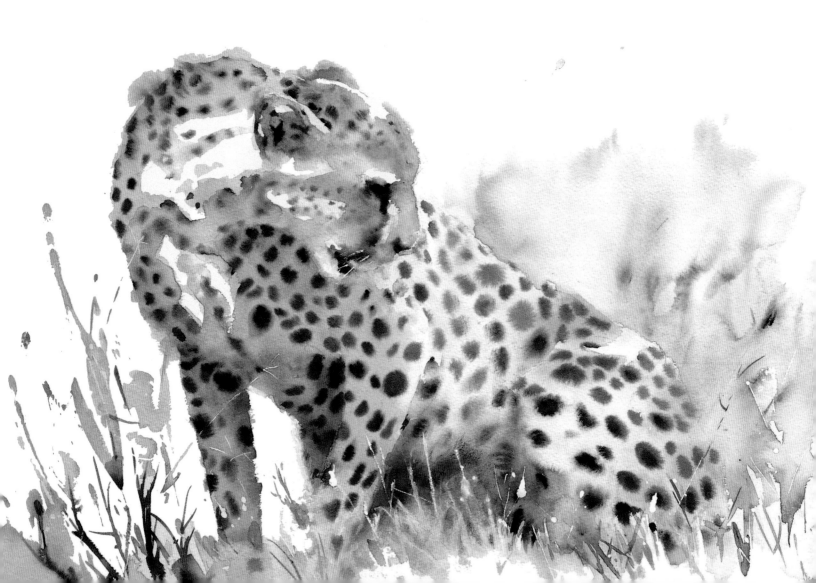

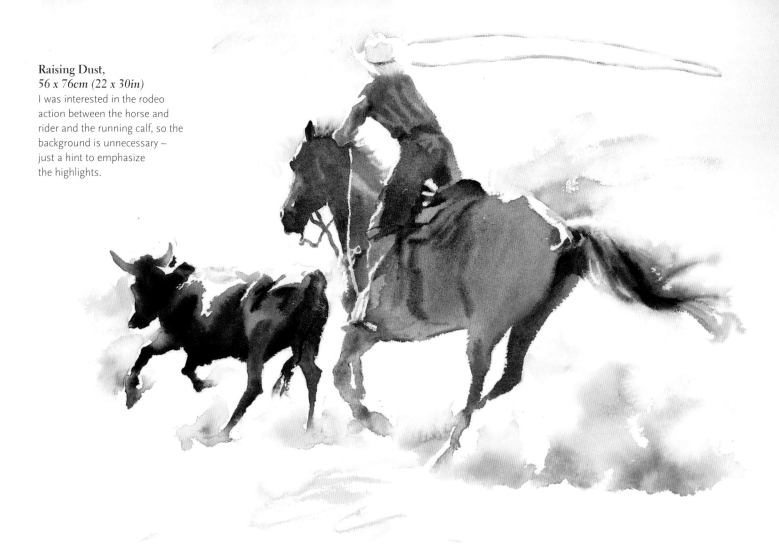

Raising Dust,
56 x 76cm (22 x 30in)
I was interested in the rodeo
action between the horse and
rider and the running calf, so the
background is unnecessary –
just a hint to emphasize
the highlights.

Ratio of Light to Shade

The arrangement between the light and shadow is what counts in the design of the painting, transcending the physical boundaries. The amount of shadow in relation to the amount of light depends on the angle of the light, and more shadow tends to emphasize the light simply because scarcity grants it greater effect.

Artistic licence allows you to move things around to balance the composition and enables you to command what matters, by downplaying or rejecting superfluous information. Accentuate your focus – if a dark tone would draw too much attention to something other than the focus, paint it lighter. Look at the work of Winslow Homer. He was masterful at seeing the major shapes and casting away confusing detail. You are under no obligation to re-create the real world; your task is to create something new that has not been seen before. You are allowed to put in and leave out whatever you want.

If your paintings are looking bland or dull, exaggerate the hues and tones, mix purer colours and increase the contrast.

Patterns of light and dark

On a sunlit day, go out into your local environment (mine, shown here, is the Fulham Road in London) with paper, brush and black watercolour or Indian ink. Find a view facing towards the light and paint a loose composition in monochrome using three main values: white paper for the light, neat black for the darks, and greys for the mid-tones. Paint the darkest tones first – the figures in my case – then wash in a mid-tone background, leaving highlights as untouched white paper. Once the composition is established, create more tonal variation with a range of intermediary tones.

Think of the subject of your painting as a design problem waiting to be solved. Try to be objective. If you identify with your subject too much it will distract you from your aim – to paint the light and shade.

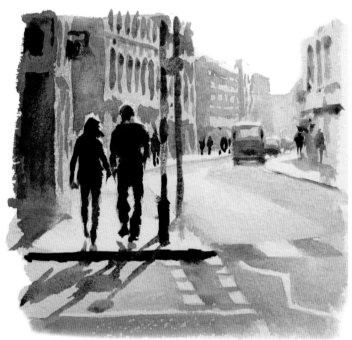

DISCOVER

- With just three tones a composition is readily laid out.

- Three main tones establish space by tonal recession.

- Transitional values fall between the darkest darks and the highlights.

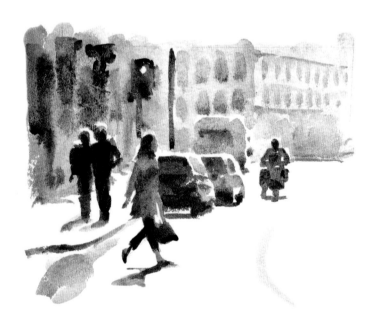

Paint several compositions, each time adding a little bit more information. Use a variety of transitional tones and highlight the shapes, lightly drawing the composition beforehand if necessary.

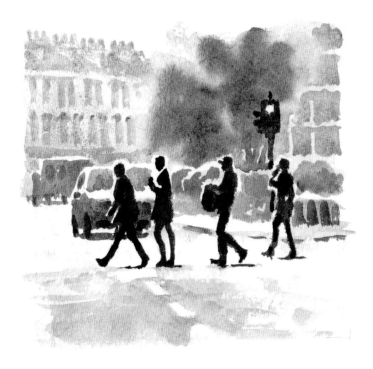

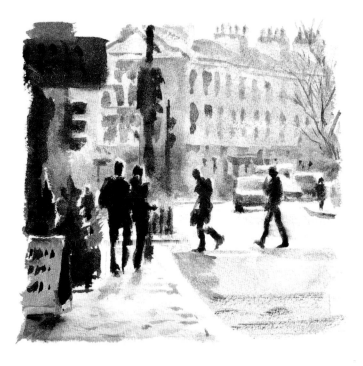

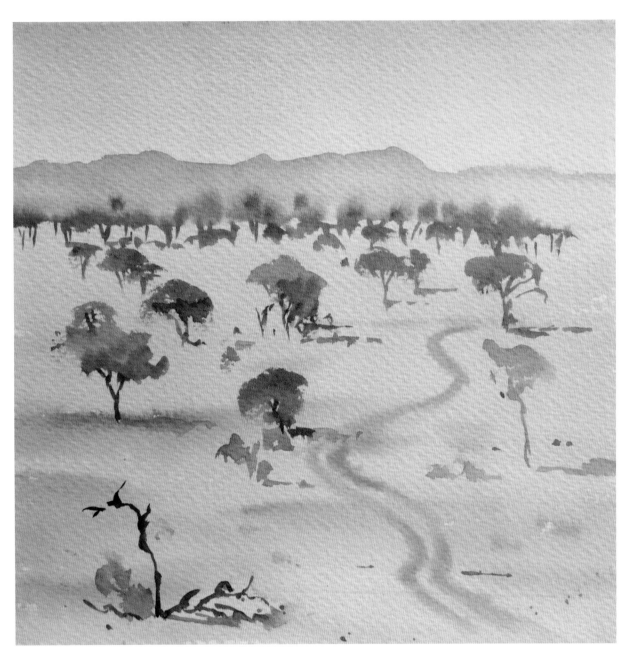

Tracks in the Serengeti, 28 x 25cm (11 x 10in)

Compose Pleasing Ratios

Establishing the light and shadow of individual components within a composition

Now that the importance of the overall design and the need to see the shapes, colours and tones as a pattern has been established, it is time to look at the light and shade of the individual components that make up the pattern. The focus of the painting is usually the element that inspired you and therefore the area you want the viewer's attention drawn towards. To maintain a focal attraction, other areas of the painting may have to play supporting and secondary roles in order to direct the eye to the main event. Selection comes into play here: what to leave in, and what to leave out.

Entertain the Eye

To reach the heart, mind and soul of the audience, the arts use entertainment. The art of painting is to entertain the eye. The initial appeal is therefore visual; it begins through the eyes before it can enter the soul. Entertainers use variety to maintain interest and painting is no different. A variety of shapes, colours and values are attractive to the eye; too much repetition loses the audience, while too much information may confuse. Variety feeds on comparison and contrast.

Set lighter tones against darker tones, and darker tones against lighter, to reinforce each other by comparison. The greater the contrast between the light and the shade, the stronger the light will appear. To maintain the chief interest, the rest of the painting may have to take a back seat. This could mean lessening a deep tone, softening an edge or muting a bright colour to prevent it from drawing the eye away from the focus.

**Keep it Simple –
A Picture Plane Checklist**

- Strong tones advance
- Pale tones recede
- The greater the value range in an item (more contrast) the more it advances
- Less definition and contrast recedes
- Warm colours (veering towards red) advance
- Cool colours (veering towards blue) recede

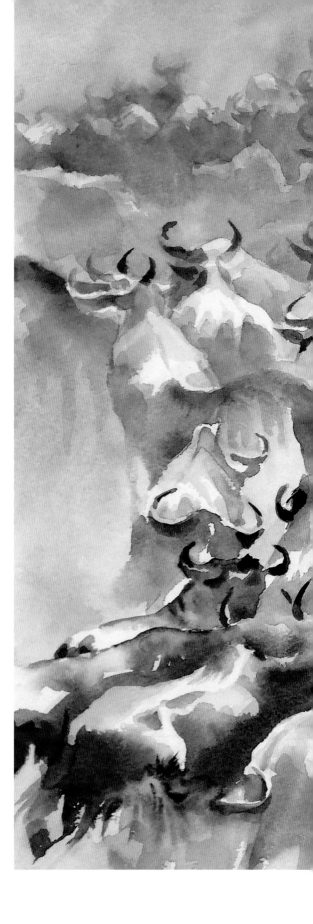

**Serengeti Abstract,
the Migration,**
56 x 76cm (22 x 30in)
With pale tones in the distance and stronger tones in the foreground a sense of distance is created. The wildebeest in the foreground are painted in a range of tones from bright light to deep shadow, whereas the distant animals are shown by a narrow range of tones with less definition, and in the far distance even less.

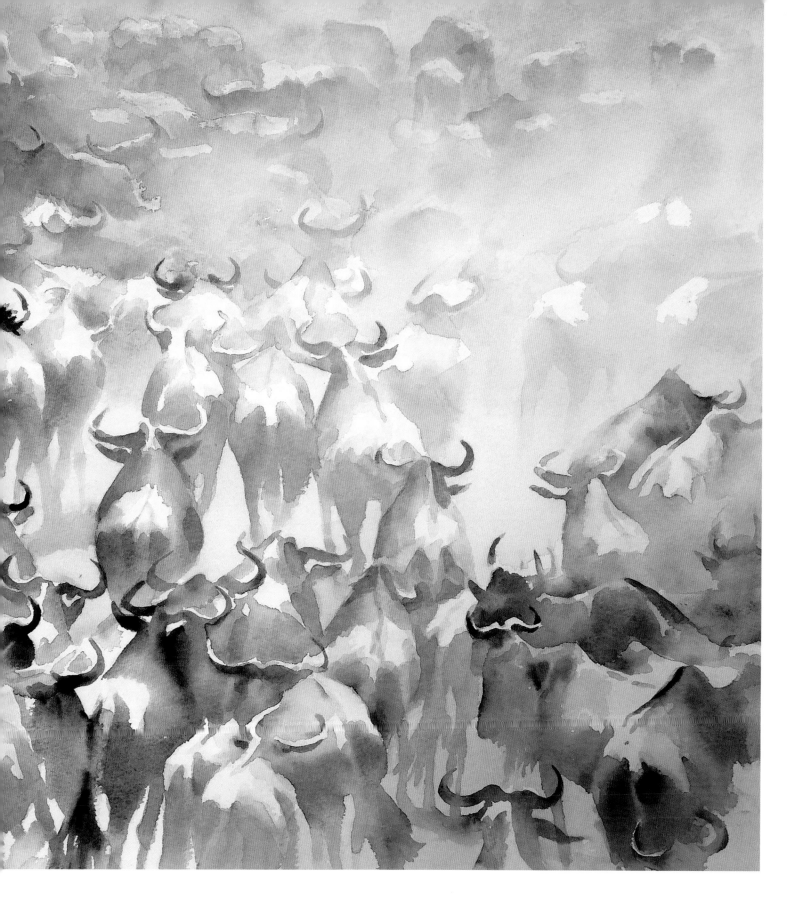

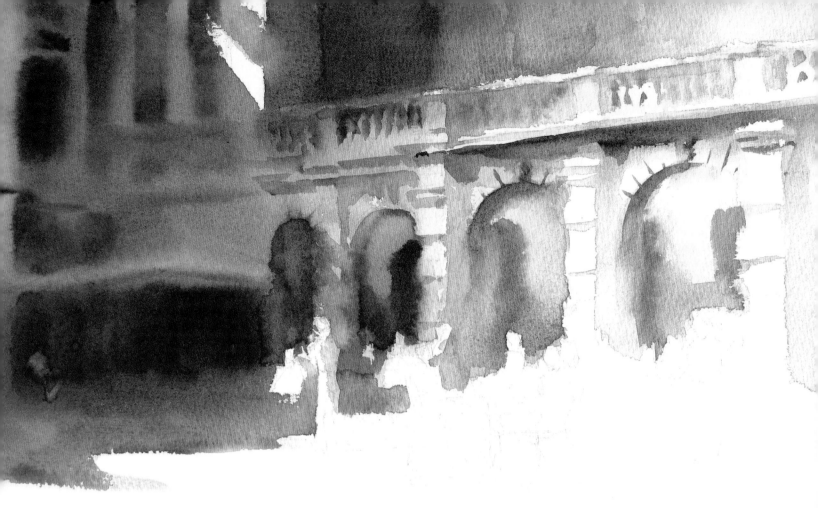

Stage 1

Over a light pencil drawing, the area in shadow is brushed in as one linked wash from left to right, starting with Burnt Umber and Ultramarine Blue, and lightening to Yellow Ochre by the time it reaches the reflected light in the shadows under the arches and architectural details.

Relativity

Tone is relative. The only way to assess tone is by comparison. Once the darkest and lightest values are noted, the differences between individual and adjacent tones can be gauged more easily as they must fall in between the two extremes. I ask myself, 'Is this area lighter than or darker than the adjacent area?' and 'How does it relate to the darkest/lightest value in the subject?'

I usually establish the main values with broad washes at the outset. These become the foundation for the surface detail, ensuring that the light and shade is coherent and consistent. Lighter details can be conserved within these washes with masking, retrieved later by lifting off, or added with bright opaque paint (see chapter 5).

Stage 2

To suggest figures in the shadows here, the Burnt Umber and Ultramarine are lifted off with a small damp brush, to 'reveal' faces, table tops and limbs, the flesh is tinted with Cadmium Red and Light Red and then darker details are added.

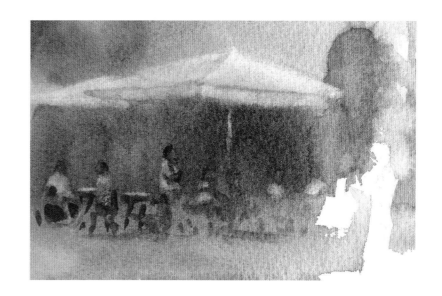

Stage 3
Light and Shade, Café at the Royal Academy, London, 28 x 38cm (11 x 15in)

In the finished painting the sunlit café and figures are added from the centre by alternating lights against darks and darks against lights, making a pattern of light and shade that gets stronger (brighter and deeper) towards the foreground.

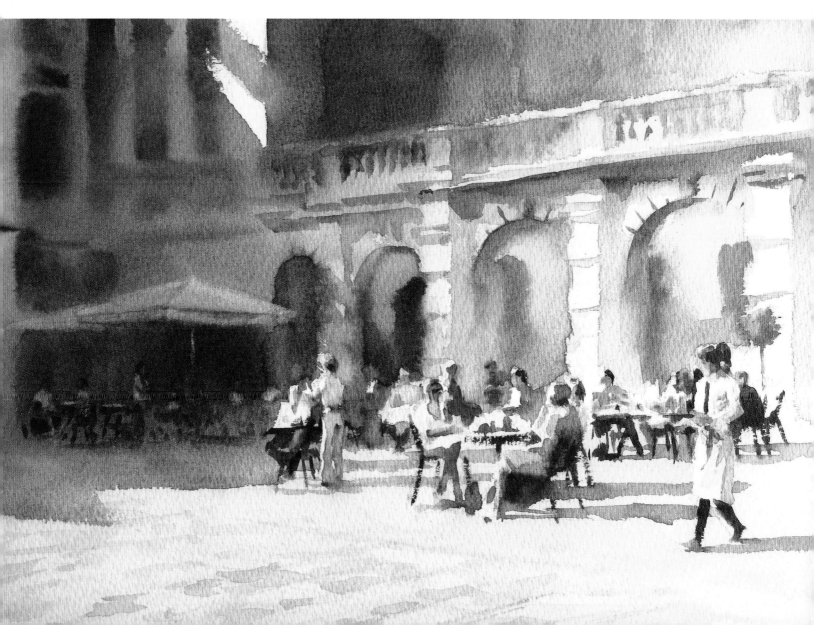

Modelling Form

The three-dimensional forms of objects are represented by a gradation of tone around the form, from light to shadow. The amount of light received by each side, whether flat, multifaceted or curved, is in accordance with the incline of the plane towards the light. Around midday, upper sides receive the most light, lateral sides less, and undersides the least. Undersides may be in total shadow or infused with reflected light. With a lower angle of the sun, early morning and late afternoon provide more side illumination. Textural detail is found in the area where light turns towards shadow – the mid-tone area.

Splash, 30 x 33cm (12 x 13in)
There can be no better subject than an elephant to show modelling of form. Here, at midday, the elephant is lit most on the top of his back, less on the sides where some texture can be seen, and is obscured in shadow on the underside.

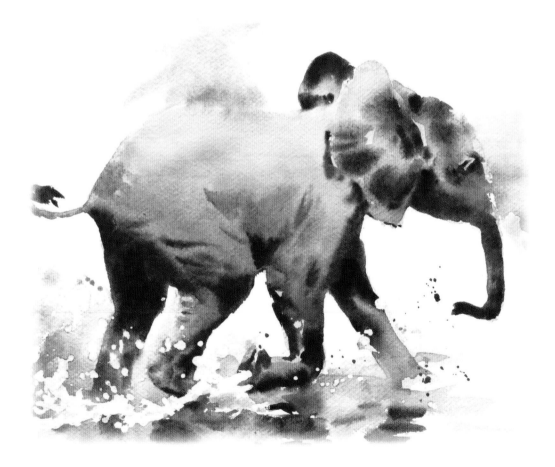

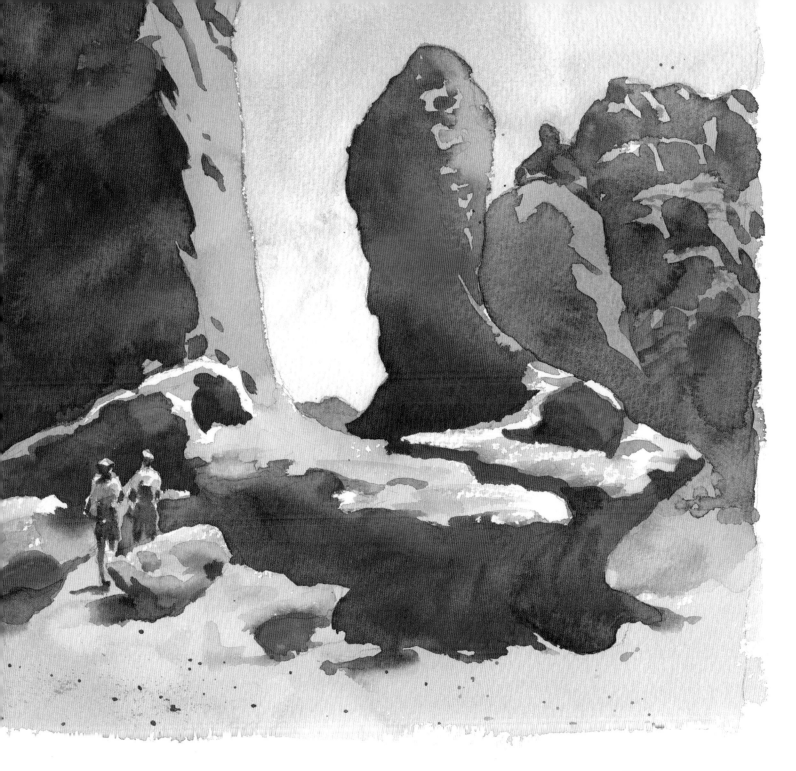

Valley of Fire, Vegas Red Rock
28 x 38cm (11 x 15in)
In this desert landscape the structural planes are clear.
The tops of the rocks are inclined towards the sun and
receive the most light, the sides are in shadow but
receive reflected light from the lit ground to reveal their
local colour, while the crevices are deep in shadow.

Reflected Light

Misjudgement in reading a tone can happen when the difference between adjacent values is given precedence over the light and shade of the whole. Reflected light is a common cause of misjudgement when it introduces illumination into areas in shadow. The shadow may appear lighter in tone than it really is, so it helps to remember where the light is coming from and which plane is therefore lit the most. For example, if the light is from overhead then the underside *must* be darker in value than the top, even though it appears lightened by reflected light. Watercolour's wet-into-wet technique provides an ideal way to infuse a shadow with reflected light and yet maintain its proper value, and shadows illuminated by reflected light can also be effectively painted with deep colourful hues. Raw Umber, Burnt Sienna or Cadmium Red, for example, are marvellous hues for representing reflected light in the shadows of sandstone. Look at the Yellow Ochre used to paint the shadows under the arches of the Royal Academy on page 57 or the Cadmium Red infused in the street shadow in *Valetta* on page 91.

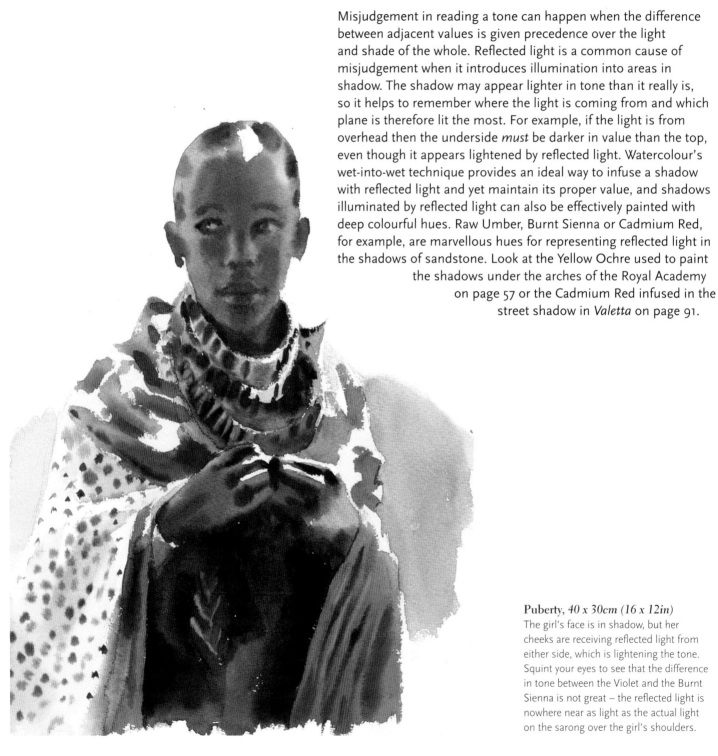

Puberty, *40 x 30cm (16 x 12in)*
The girl's face is in shadow, but her cheeks are receiving reflected light from either side, which is lightening the tone. Squint your eyes to see that the difference in tone between the Violet and the Burnt Sienna is not great – the reflected light is nowhere near as light as the actual light on the sarong over the girl's shoulders.

**Joan Looks Lovely
in Symi, Greece,
*34 x 43cm (13½ x 17in)***
The pattern of light and shade
is established at the start with a
wash of Ultramarine Blue, then
where the light reflects off the
step, very pale Cadmium Yellow
is dropped into the wet wash.
As it spreads out, the opaque/
lighter colour pushes aside
the blue pigment particles,
mingling among them, bringing
a glowing tint into the shadow
(top right). Now the figure can
be rendered in more detail.
Notice the face, where reflected
light makes the features more
visible than you might expect
under the broad-brimmed hat
(bottom right).

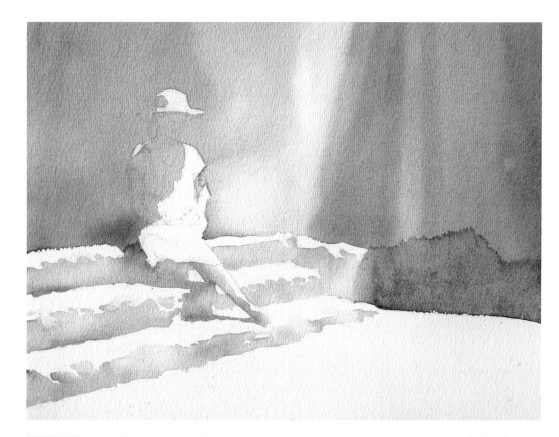

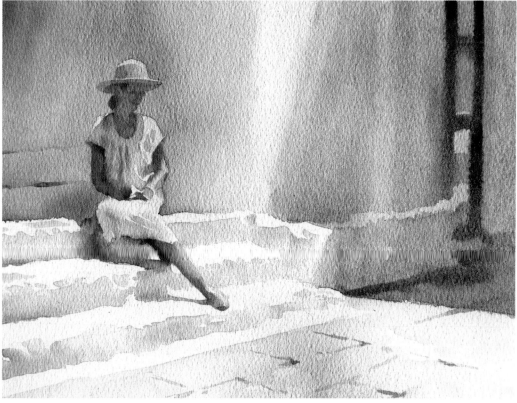

Counterchange

For the same reasons that the contrast between tonal values is able to represent form and space, so it is able to define contours and can be employed to revive the appearance of a flat or dull watercolour. By increasing the tonal

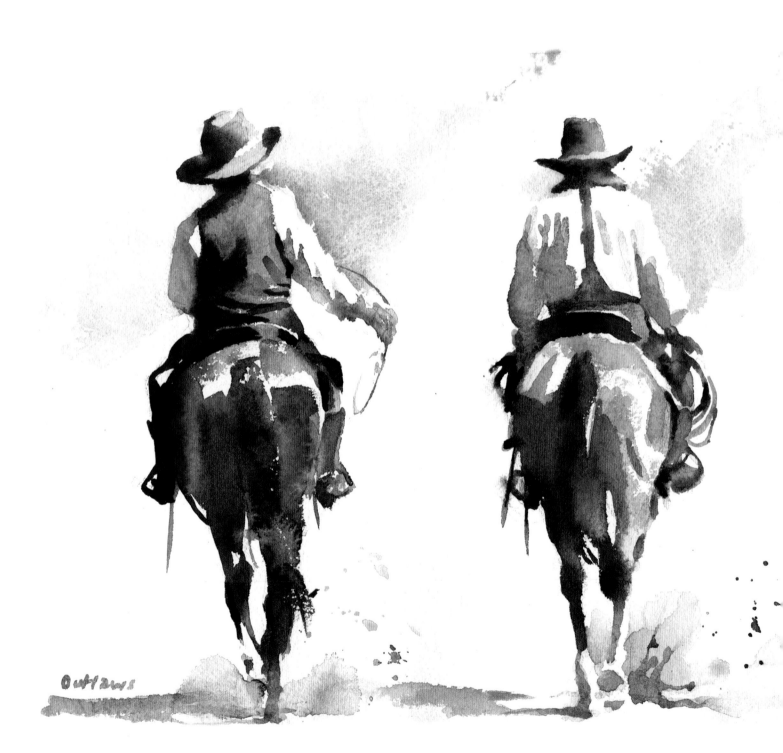

Outlaws

differential either side of a pencil line, or between different components, a change in plane is indicated. As soon as the counterchange is enhanced, contours become more evident and a flat watercolour is animated and revived.

Outlaws, *30 x 66cm (12 x 26in)*
I like to offer description by suggestion, but the white sleeves of the riders' shirts were lost in the white paper background here, so I painted patches of pale blue up against them, immediately making the shape more apparent, i.e. using contrast of tone to define the contours.

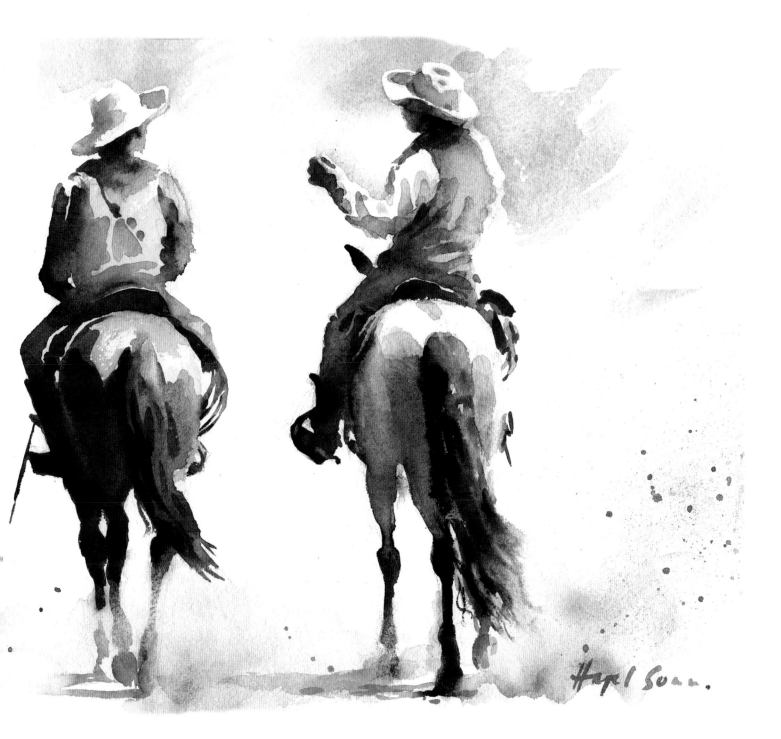

Simplifying complex structures

The eye can easily be fooled when assessing tonal values, creating all sorts of mischief with relative tone! A value will appear lighter against a darker tone than it may actually be in relation to the whole. When value is hard to determine, check out the angle of the plane to the light source, then apply logic: what is the tone likely to be given the prevailing light? In this assignment the aim is to simplify a complex composition into its main structural components and work out the tonal values of each plane. Find a complex building and study it, breaking it down into a series of geometric shapes like a stack of boxes. Make a simplified tonal sketch and then one or two watercolours. I chose ramparts on a steep cliff face in Monemvasia, Greece. Looking up, there are virtually no top sides so I had to look closely at the facets of the walls and rocks. By seeing the complex structure as different planes set at different angles to the sun, the maze of tonal values is simplified into a manageable composition.

Using a 2B pencil, make a tonal sketch of the main structural planes, defining them through use of shadow and light.

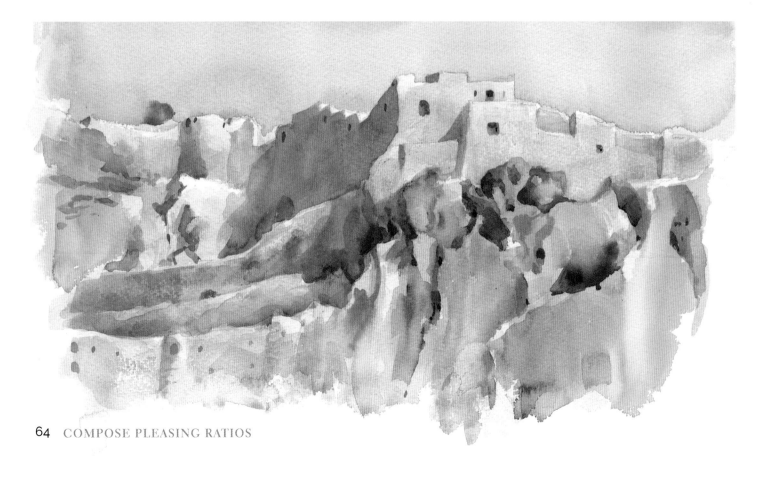

Computers could probably analyze the data from the compositions of many successful paintings and come up with algorithms for a balanced ratio of light to shadow. If so, good composition could be manufactured and predicted – an interesting thought.

DISCOVER

By finding the main facets/planes in your subject, it is easier to assess their angle toward the light, and therefore the amount of light they are receiving, and thus to simplify a complex structure into the main areas of light and shade.

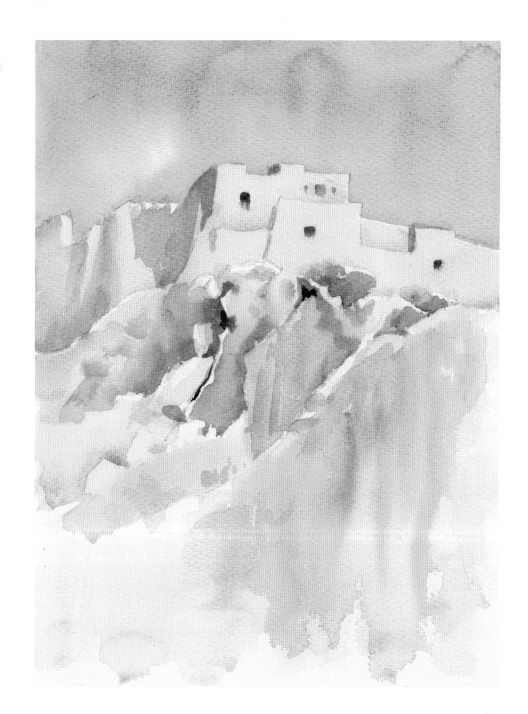

The Upper Town, Monemvasia, Greece, 30 x 51cm (12 x 20in): *horizontal format*
Here the angles of the man-made ramparts are fairly straightforward to work out with the sun coming from the right-hand side, but the cliff face, streaked with red iron oxide, peppered with deep indentations and criss-crossed by numerous ledges was complex to draw. I looked for the main facets, painted them and ignored the rest.

Perched, 38 x 28cm (15 x 11in): *vertical format*
After painting the cliff in a horizontal format I decided that it was more suited to a vertical composition. More familiar with the structure, I was able to simplify the structure further in this quick watercolour before the light came around the front face of the rampart and all the tonal values changed.

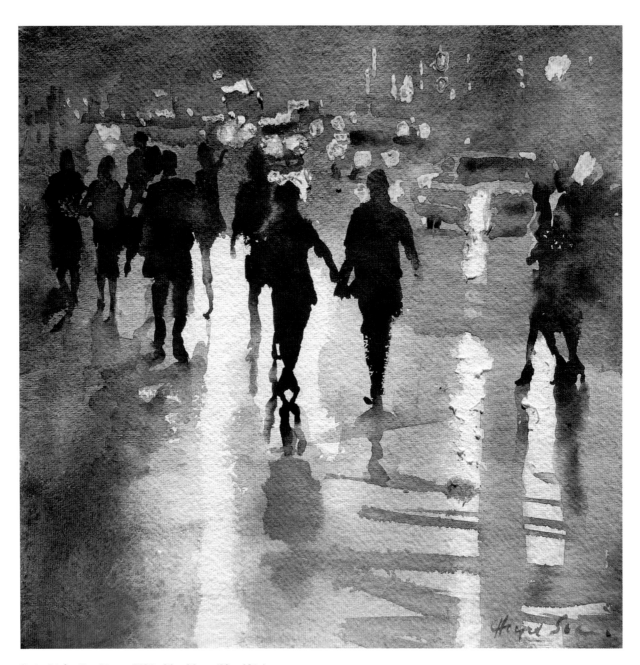

Strip Light, Las Vegas, USA, 30 x 30cm (12 x 12in)

CHAPTER 5

Conserve the Light

Methods and techniques for conserving the white paper

Though light itself cannot be painted, watercolour has a variety of methods and techniques for conserving, preserving and representing different kinds of light. Bright highlights are generated between washes with untouched white paper; the sparkle of light on water can be mirrored with fragmented strokes of a dry brush; slivers and halos of backlight can be protected with masking fluid; soft lights can be lifted out from dark washes and speckled textures implied with wax resist. The watercolour medium is adept at portraying light because its ground material, the white paper, is the source of the light. All you have to do is conserve it!

Conserving Highlights

The freshest, quickest way to show highlights in a watercolour is to leave gaps and spaces of untouched white paper between and within darker washes. This requires deft brushwork around the 'empty/negative' shapes of light. As long as they appear on the lit side of a form, the actual shapes of light do not need to be accurate and in fact irregular shapes tend to look livelier than fastidious, meticulously crafted highlights.

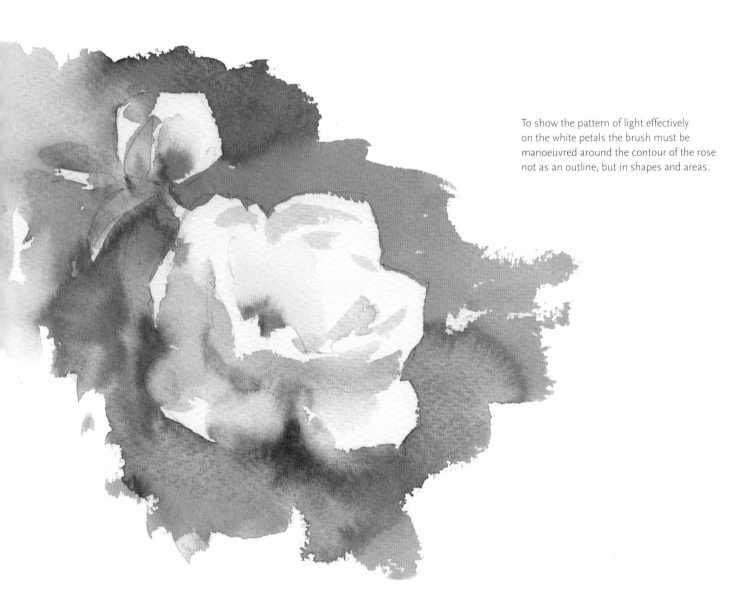

To show the pattern of light effectively on the white petals the brush must be manoeuvred around the contour of the rose not as an outline, but in shapes and areas.

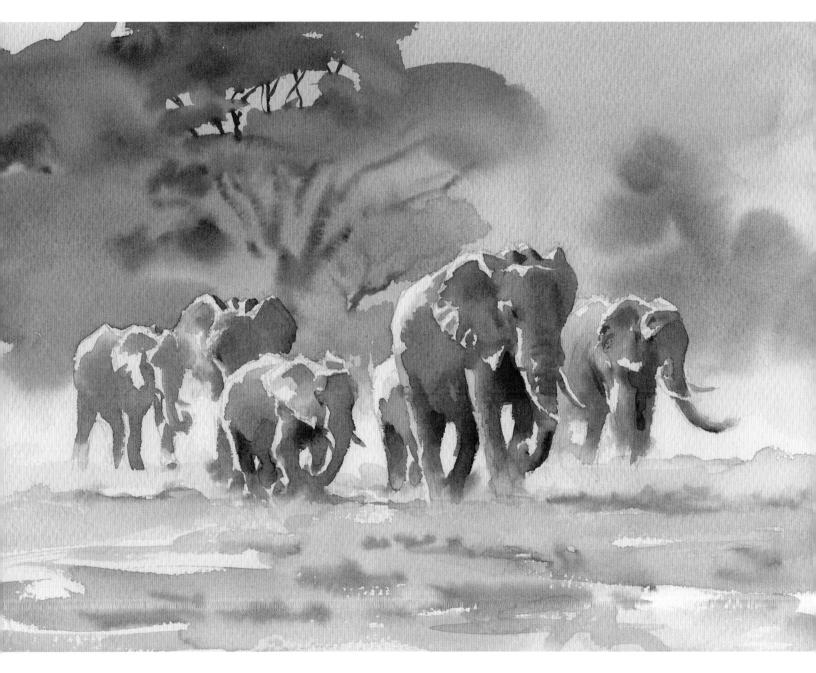

The Silent Heard, *28 x 38cm (11 x 15in)*
The irregular patches of untouched white paper representing
the light are what bring this painting to life.

Descriptive Highlights

The characteristics and texture of a form can be described by the nature of the highlight and shadow, showing whether something is angular or curved, shiny or matte, rough, plush or smooth, soft or hard.

Strong contrast between light and shade indicates bright light. Bright light has a dazzle effect on colour, which bleaches and inflates highlights. To illustrate this, bright colours can be left untinted and highlights even increased in size.

Flickering light has multiple highlights, shown by a plethora of gaps within a wash. For example, in seascape and landscape, flickers of light scattered across the subject create the impression of sunlight dancing on water or leaves.

White paper cannot be easily retrieved once covered, so err on an excess of negative space to begin with. Any surplus can always be tinted later.

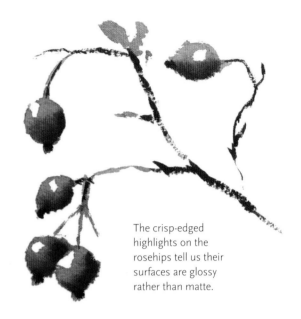

The crisp-edged highlights on the rosehips tell us their surfaces are glossy rather than matte.

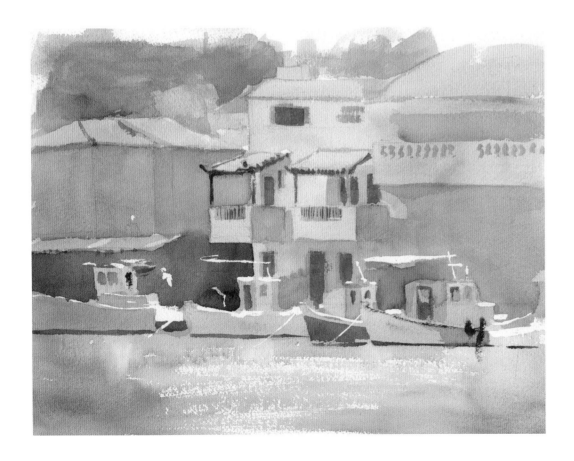

Boats, Elafonisos, Greece (Unfinished),
30 x 40cm (12 x 16in)
The initial layers in this watercolour demonstrate that crisp edges denote angular form. They also infer/confer visibility and therefore proximity. The broken brushstrokes in the water tell us the sea is backlit and ruffled by a small breeze. The dry brush mark is a broken, fragmented brushstroke delivered laterally across the top of the paper surface, using thin damp/dryish paint, from the side of a brush. The aim is to skip the paint across the tooth of the paper, touching the top and missing the valley.

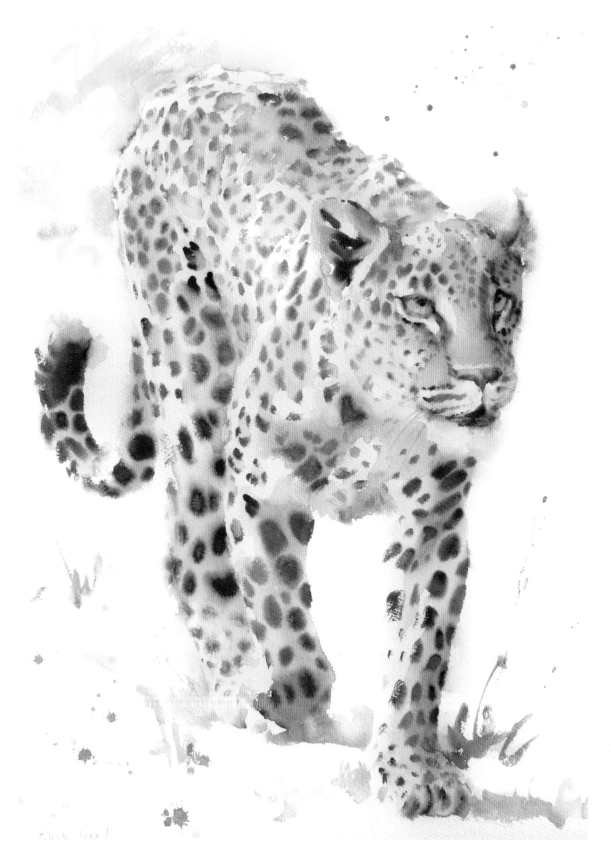

With Cat-like Tread,
76 x 56cm (30 x 22in)
The softly blended
wet-into-wet exchanges
between the light and
shade on this leopard
describe the soft, furry
texture of her pelt.

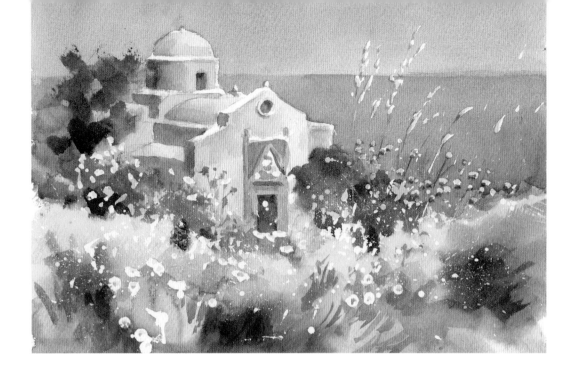

Agios Nikolaos, Aegean Spring, Greece,
28 x 38cm (11 x 15in)
The multitude lights of small daisies and narrow grasses were guarded by masking fluid, painted onto the paper before any paint was applied. When the over-washes were fully dry, the masking fluid was rubbed off and in some places the revealed white paper was tinted, enabling a pleasing exchange of light against darker tones.

Reserving the Light

It may not sound hard to leave out 'negative' shapes within a wash, but it is easier to paint the positive shapes made by actual brushstrokes than to not paint the shapes of light left between them! Thankfully there are several aids and techniques for conserving the light, which free up brushwork and washes and alleviate anxiety.

Masking

Masking fluid is a pale, creamy coloured latex liquid used to reserve small areas of light and highlights in a painting. It is applied with an old/cheap brush before painting begins, allowed to dry thoroughly, and then painted over. When the paint is dry, the latex is removed by rubbing off with an eraser or fingers. If the retained highlights look too bright or a bit blobby they can be tinted or tidied up.

Salt crystals

When salt crystals are scattered into a rich, wet initial wash, they draw pigment out of the water and into the crystals, creating an attractive, mottled pattern. A multitude of fine spots of light within the wash are created with fine crystals; larger salt crystals make more irregular patterns as their circles of osmosis spread out and overlap.

The salt crystals have been tossed at random into the wash to create texture in the pantiled roof. You can see the pattern emerging around the crystals in the wet paint.

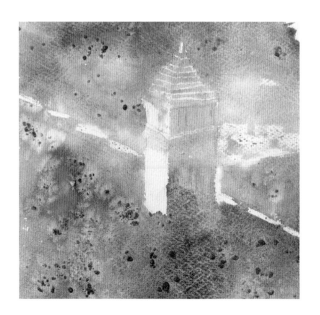

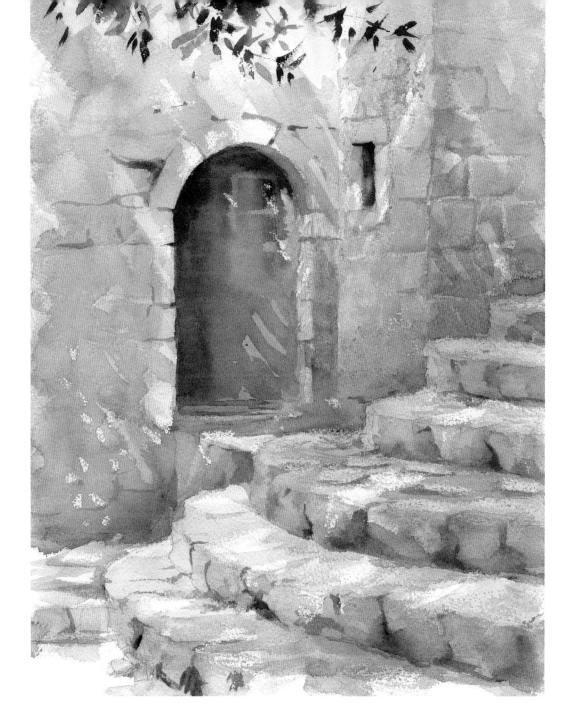

The Door in the Wall,
40 x 30cm (16 x 12in)
Wax has been used to
preserve the light on the
steps and wall and to create
texture on the stone.

Wax resist

Wax resist uses the repellent nature of wax towards water to create the textural lighting of rough surfaces. A wax candle or white wax crayon is rubbed or drawn over areas where light is to be reserved. Watercolour washes can be painted over the top immediately. The wet paint is repelled by the wax and leaves a textured trace in its wake. The wax cannot be removed so be careful not to place it anywhere but where you want to portray light. This technique is ideal for rough surfaces and ruffled water.

Retrieving Light

There are several ways to retrieve or reintroduce light from the white paper after it has been covered with watercolour paint. These techniques can be used intentionally or as troubleshooting methods to retrieve lost light.

Opaque white

Because Titanium White is opaque, fine light details, like the narrow stems of some of the daisies and the rim of the pot, below, can be painted over the darker wash. Titanium White is ideal for small corrections.

Scratching off

The side of a sharp blade carefully skims off the very top layer of the paper removing the paint and revealing clean white paper for a few of the daisies below. The paper underneath is no longer protected by size on the surface of the paper, so scratching off should only be done when a painting is completely finished.

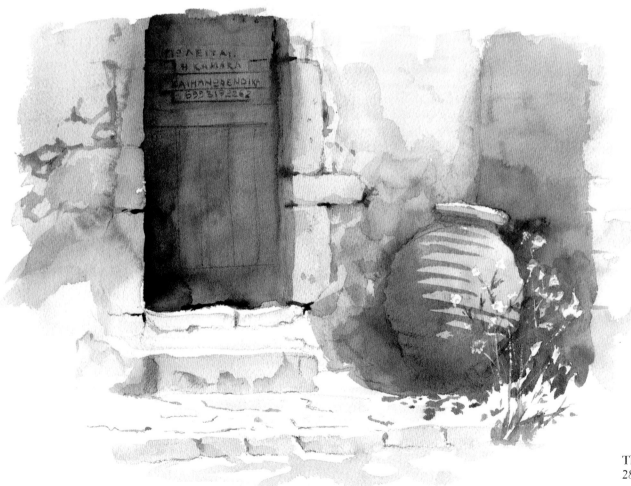

The Door Ajar,
28 x 38cm (11 x 15in)

Dropping in

While a wash is still wet, dropping water into the middle of a patch of paint dilutes the colour, reintroducing light. The ragged edge of the lioness's beard is created in this way.

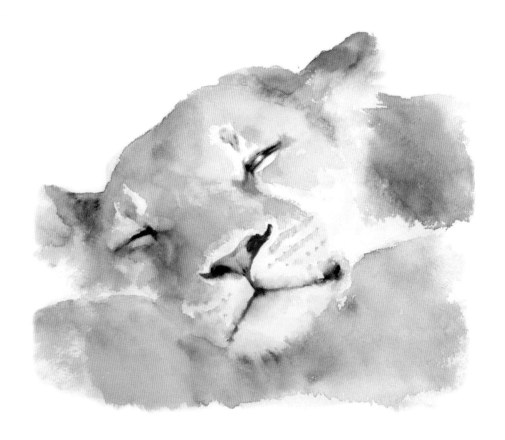

Sponging off

A damp sponge vigorously rubbed over the paper can lift off a considerable amount of pigment. In the picture below, stencils were cut in the shape of a few sail boats and the pigment sponged off to restore the white of the paper.

Lifting out

Most watercolour pigments are staining colours – their fine particles creep into the cotton fibres and thus stain the paper surface – but the pigments with larger particles, such as the earth and metal colours, can be lifted out from the paper to a greater or lesser extent with a clean damp brush. Here Ultramarine Blue and Burnt Sienna are lifted off to create the sail boats in the distance.

Masking: reserving the light

Choose a backlit subject that exhibits small slivers of light that would be hard to preserve from a broad wash without the aid of masking fluid. I chose two cowboys riding out at dawn. There are fine highlights on the backs of the horses and fence rails.

Draw the composition. Use masking fluid to preserve the small highlights and wait for it to dry completely before painting.

Stage 1

Over the dried masking, I washed in the golden light with Indian Yellow and Yellow Ochre and the shadows and ground with Ultramarine and Burnt Sienna. The painting was then built up in a few layers. As the underwash was deepened to show the corral the masking fluid slivers became more visible.

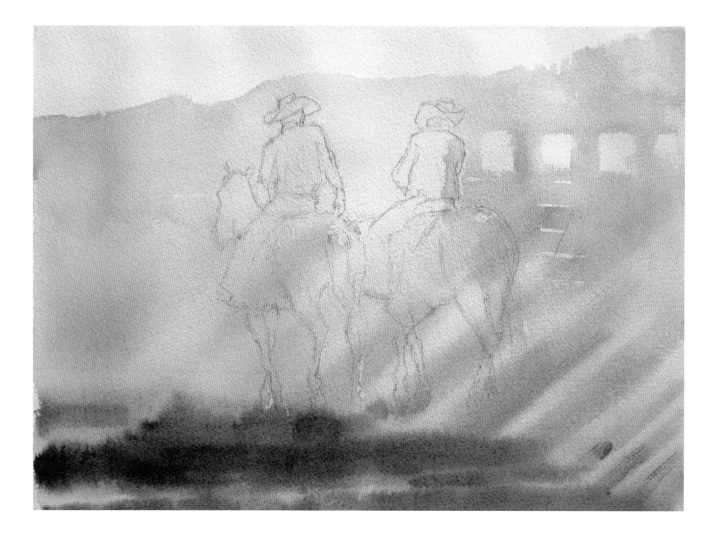

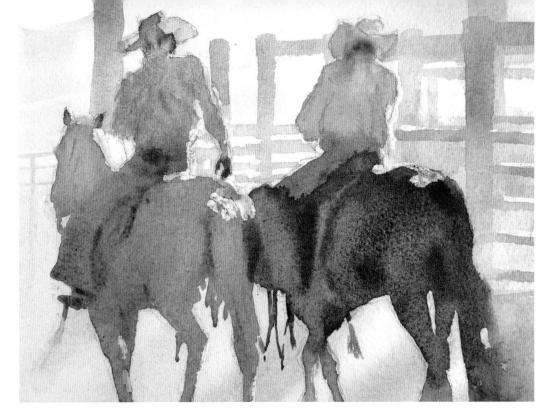

Stage 2
Once the hazy dawn light of the background was established, I was able to paint the horses and their riders. I could then rub off the masked highlights with a gum eraser.

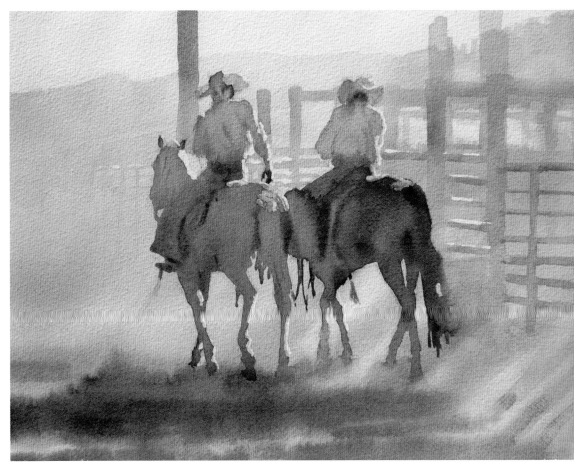

Stage 3
Riding Light,
28 x 38cm (11 x 15in)
When dried masking fluid is rubbed off, the reserved highlights may appear too bright, bland or blobby in relation to the rest of the painting. To smooth the starkness here, I tinted the light on the rumps of the horses.

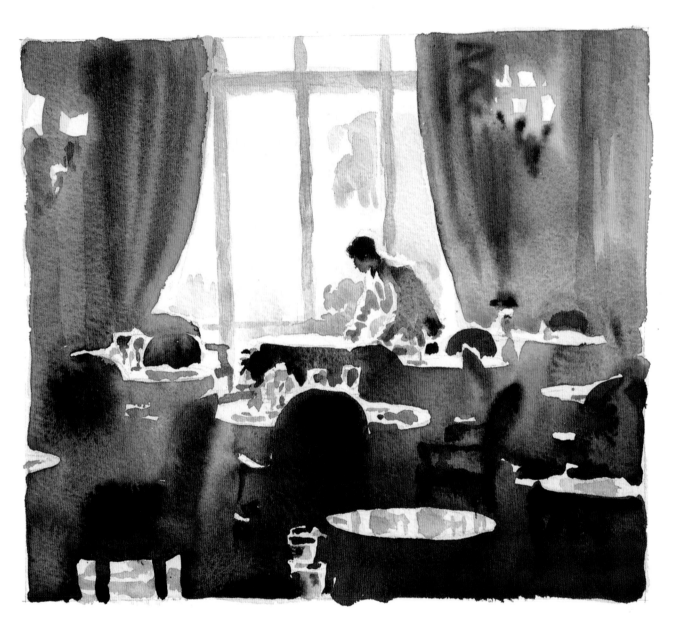

The Ritz, London Waiting, *25 x 25cm (10 x 10in)*

Prime Your Values

Mixing the right tonal values

You are aware of the patterns of light and shade and know the ways to conserve the light. Now it is time to concentrate on individual and relative values – tinting the light, painting the shade, managing the mid-tones. Tone is king over colour; when you get the values right the colours largely look after themselves. Mixing or layering colours to reach a desired value requires observation, but understanding that values are relative to each other, not absolute in themselves, immediately relaxes the pressure to paint an exact tone. The aim is to maintain a credible range of values within the painting and retain maximum transparency in as few brushstrokes and layers as possible. To achieve this balance be gentle and economic in the light, and bold and generous in the shade.

The Pitfalls of Overmixing

As the colours of pigment are added together, wavelengths of light are successively subtracted. Thus the three main colours – the primary hues, red, yellow and blue – add together to make black, brown or grey and so, by its very nature, pigment mixing leads to darkness. The dirty water in the rinsing pot is a good witness to this tendency and is muddied further by the rinsing of opaque pigments. The challenge then, in watercolour, is to blend colours together that do not become dull as they darken but remain vibrant and transparent.

Manufacturers of artists' watercolours make as many colours as possible in their range with single pigments to aid clarity in mixing. The artist's part is to limit the number of colours in any one painting and mix, blending on the palette with as few different pigments as possible. This ensures clarity, encourages harmony and, by interaction (since colours offset each other), makes the watercolour appear more colourful.

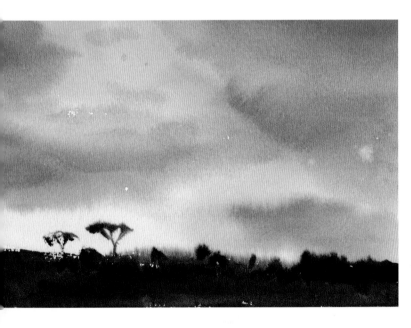
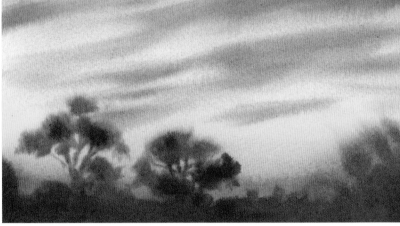

Three transparent colours, Permanent Rose, Prussian Blue and Aureolin in the painting above left, mix to a deeper black for the silhouette of the landscape than the three opaque colours in the painting on the right – Cadmium Red, Cerulean Blue and Cadmium Yellow.

Primary Values

Each primary hue comes with an inherent basic tone. Blue is by nature a deeper tone than red, and red a deeper tone than yellow, but the degree of transparency determines the depth of value each hue can offer or achieve in a mix. Transparent versions mix to deeper, more transparent darks, and opaque pigments lighten, mute or dull a mix.

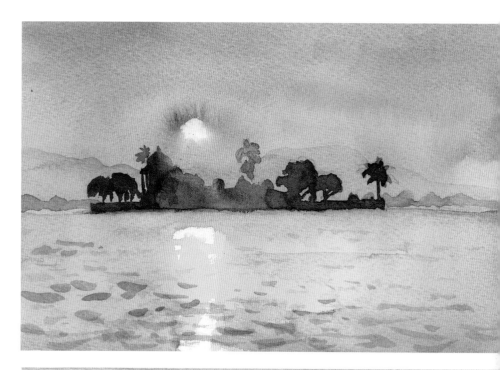

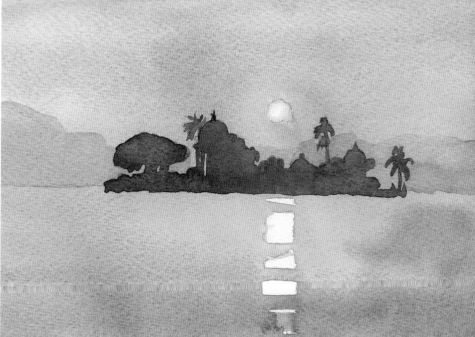

Compare these two sunsets painted on Lake Pichola in Udaipur, India. Both mixes use predominantly opaque colours but the mix that includes a transparent colour (above right), is able to make a subtly darker tone for the silhouette of the island.

Deepening Hues

Mixing the dark tones requires generous amounts of pigment. At first sight, adding black or grey to darken a hue might seem a quick way to achieve a deeper value but it makes for rather dull mixes. To deepen colours in watercolour use other hues from within the palette already chosen for the painting; alternatively include a deeper version similar or adjacent to the hue – violet or crimson to deepen red, and blue or brown to deepen green. Colours can be darkened with the addition of an opposite colour or in a lively manner with transparent blues. I use Ultramarine for a warm bias and Prussian blue for a cool bias.

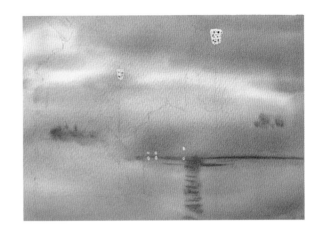

Overnight Rain, Venice, Italy, 25 x 35cm (10 x 14in)
The palette chosen for this painting was Ultramarine Blue, Quinacridone Red and Indian Yellow, as seen in the background underwash for the sky (shown right). A mix of these three colours was used to make the darker tones, the figures and balustrade, and to mix the black of the lamp posts.

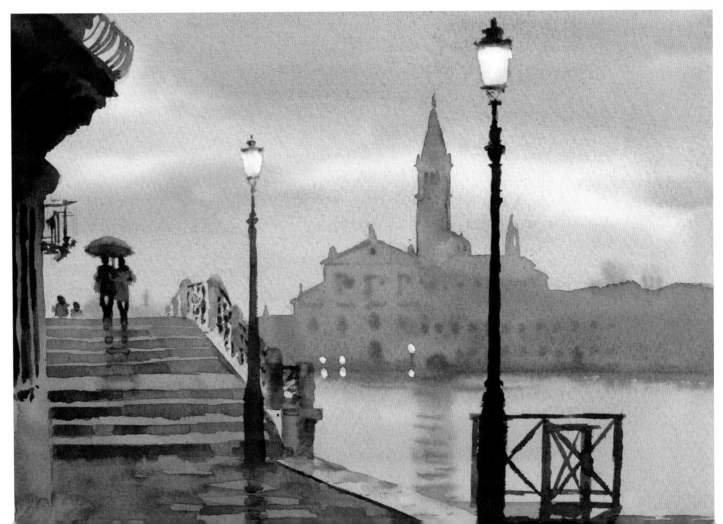

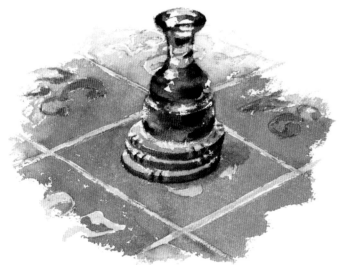

Here the blue of the glass marker is simply deepened with a more concentrated mix of the blue wash, and the red sides of the gambling chip are deepened with Alizarin Crimson.

Darkening with Opposites

Being the primary absent from a mix of the other two primaries, an opposite colour, darkens a mix by default (because all three primaries are now involved). Mixing opposites is therefore a good way to make attractive browns, blacks and greys with the minimum of two pigments. Thus an orange (yellow + red) added to its opposite blue makes a vibrant black, grey or brown. Be watchful, however, as mixing opposites also has the ability to neutralize and therefore dull a mix.

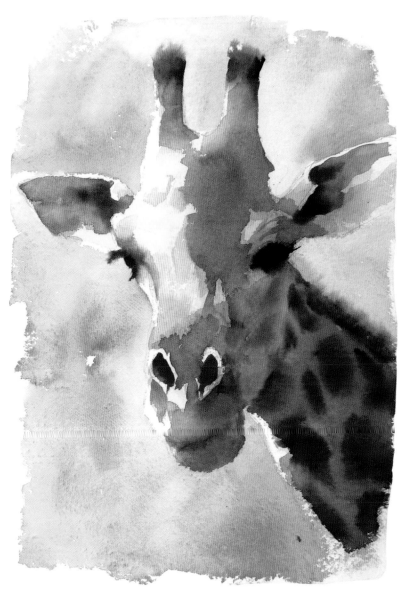

Giraffe, 51 x 38cm (20 x 15in)
Orange and blue are opposite colours. Here the shadows of the orangey hide of the giraffe are darkened with the same blue used to paint the sky.

Don't Be Afraid of the Dark

Deepening colours can require patience if you are not used to working with rich dark or deep mixes. Watercolour dries to a lighter tone than it appears when wet, so go in deeper and darker than the value you are planning to achieve. Check the consistency of the mix: deep dark colours will not need much water, so if the paint is pooling in the palette it is probably too dilute. Sloping palettes are designed to show, by gravitational flow, the actual consistency of the mix (see page 87). Be bold and direct, and maintain transparency with single or few layers, rather than by hesitant increments.

Mixing black

There is no need for ready-made black or grey in the palette because these colours can be made from mixes of red, yellow and blue, or with mixtures of opposites or near opposites, such as blue and brown. I frequently mix blacks from Ultramarine Blue and Burnt Sienna and may add transparent violet or Alizarin Crimson to increase warmth and deepen tone. Blacks, browns and greys mixed on the palette require concentrated pigment; on the paper they can be deepened wet-into-wet by adding intense, almost dry, pigment until the required value is reached. Transparent colours make the deeper blacks and browns. Layering tends to make duller darks because successive layers gradually blot out the light reflected back through and between the pigment particles.

Companions, 10 x 15cm (4 x 6in)
Indigo and Sepia make a great blue/brown mix for the neat black of the penguins' suits.

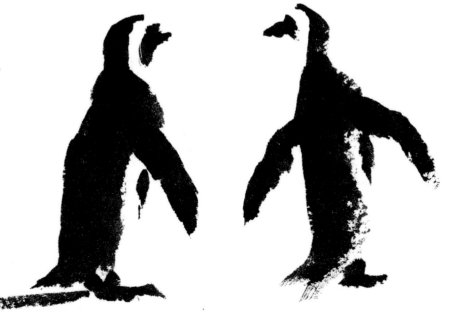

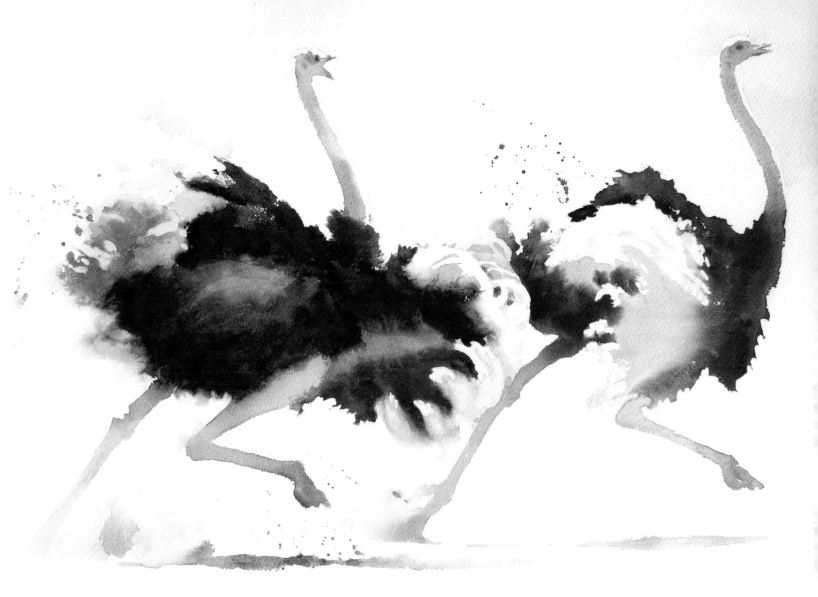

Feathers Flying, 55 x 76cm (22 x 30in)
Here Prussian Blue, Burnt Umber and Alizarin Crimson
are mixed to paint the black for the ostrich feathers.

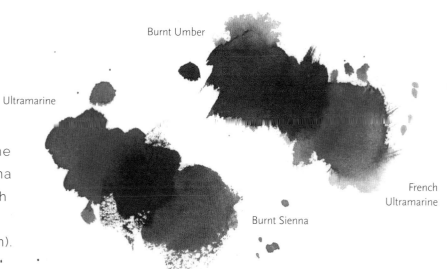

Burnt Umber

Ultramarine

For deep black, mix Ultramarine
(Green Shade) with Burnt Sienna
(a reddish brown) or mix French
Ultramarine (Red Shade) with
Burnt Umber (a greenish brown).

French
Ultramarine

Burnt Sienna

Tinting the Light

Watercolour pigment dilutes to a wealth of glowing tints for the lit areas in a painting. The transparent colours offer radiant tints and the opaque colours bring brightness.

In its concentrated form, artists' watercolour pigment is very intense. Very little pigment is needed to make a pale tint, which is diluted with water on the palette. Being dilute, a tint is transparent or translucent, but still appears freshest in the initial layer over the white paper, so aim to mix the right value for the first application rather than relying on increments. In many of the paintings in this book, the areas that are highlighted (not the untouched white paper) were tinted using an underwash laid at the start of the painting. This is often variegated as it is laid, changing in temperature or value across the paper (see *Riding Light*, pages 76–77).

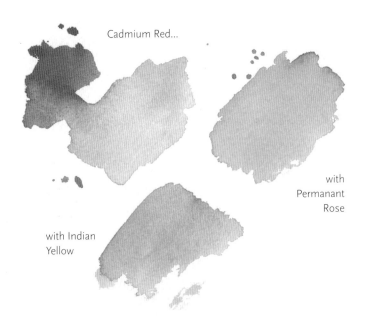

Cadmium Red...

with Permanant Rose

with Indian Yellow

Bright opaques, such as Cadmium Red, lose their chromatic intensity with dilution so the hue can be boosted by adding a minute amount of transparent pigment. For example, Indian Yellow or Permanent Rose added to dilute Cadmium Red make the hue appear more radiant.

The transparent colours, Violet, Ruby Red (Permanent Rose), Sap Green and Indian Yellow, dilute with water to become glowing tints, representing perfectly the radiant hues of the flowers.

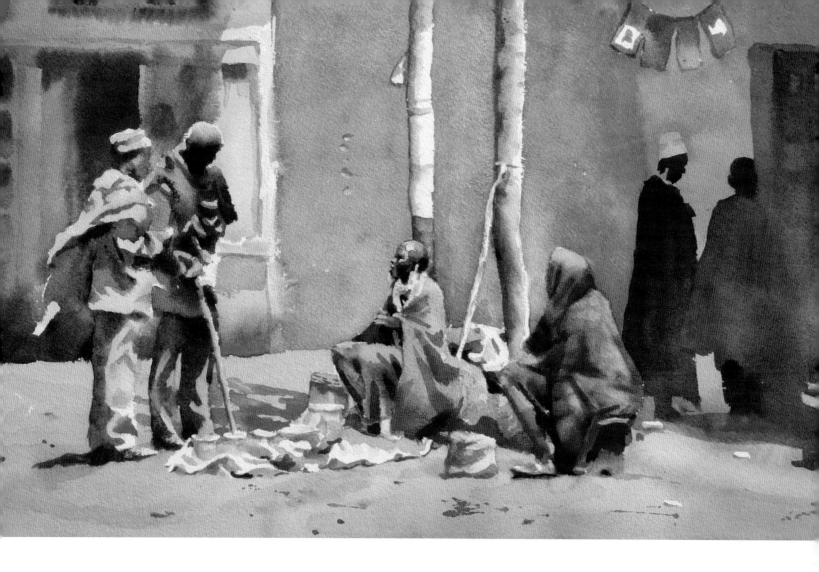

How Much Water?

A sloping palette is a huge benefit in mixing because the consistency of the paint is clearly shown by the gravitational flow on the slope. If a mix becomes too thin, wet or runny, the paint runs into the gutter as 'tinted water' and ceases to be a useful tint for painting. Pooled water looks deeper in tone than the true value, which is displayed in the trace left higher up the slope. In its natural grip on the gentle slope of the palette, the surface film is a useful guide to the consistency of a mix.

Likewise on the paper, very wet or pooling paint is an excess, and looks deceptively deeper in value than the tone to which it will dry. Draw out pooling paint with the tip of a brush or the corner of a towel so as not to disturb the wash. Colour should only be allowed to puddle on the paper if you are actively seeking a backrun, which is a lovely characteristic of watercolour painting when intended but may ruin the appearance of a wash if accidental.

Kenyan Conversations,
35 x 51cm (14 x 20in)
This painting is a patchwork of brightly lit walls and fabrics employing the brightest attributes of a bevy of opaque colours: Light Red, Cadmium Red, Cobalt Blue and Cobalt Turquoise. A dash of Transparent Orange is added to the pale Cadmium Red on the central cloak to lift it to a more radiant tint.

Managing the Mid-tones

The deepest darks and lightest tints are responsible for the dynamic in a composition but it is in the province of the mid-tone, where light turns to shadow, that detail is implied or described. Mid-tone areas often account for the majority of a painting, transitioning from lighter to darker mid-tones.

In the physical subject, the variety is often so great it can be confusing. Half close your eyes to eliminate unnecessary detail so you can concentrate on what counts. Here in the mid-tones the art of reading, judging and mixing values really matters because relative tone can be misleading. A tone may appear lighter than its value simply because it is adjacent to a much darker area. Keep in mind the whole painting: measure the mid-tones not only in relation to close neighbours, but those further away, always asking, 'Is it darker than, or lighter than?' Check whether the tone you have mixed makes sense with the light source and fits in the range between the main highlights and deep shadows.

Just as watercolours are built up from light to dark, it pays to work from paler to darker mid-tones, particularly if you are representing depth or distance. For example, build a landscape from paler background features to an increase in value and contrast in the foreground.

Field sketch
15 x 20cm (6 x 8in)
Increasing the values by increments, either by layering or adding colours wet-into-wet, makes the representation of space managable.

Freya, 30 x 33cm (12 x 13in)
Freya's head, ears and neck are swathed in a
delicate alternation of warm and cool mid-toned
shadow. Prussian Blue provides the cool bias,
while Burnt Sienna over Yellow Ochre brings in
the warmth and, with dashes of violet, gently
increases the depth of darker mid-tones.

Colour-fuelled Shadows

Wet-into-wet blending is ideal for painting colourful shadows. Paint a base wash in a lighter tone than the shadow value, then brush, drop or touch in additional colours, each in a successively drier consistency to account for the diluting effect of the water already on the paper from the previous wash. Remember, transparent colours deepen the washes and will darken the shadow while bright opaques lighten, and can introduce the effect of reflected light.

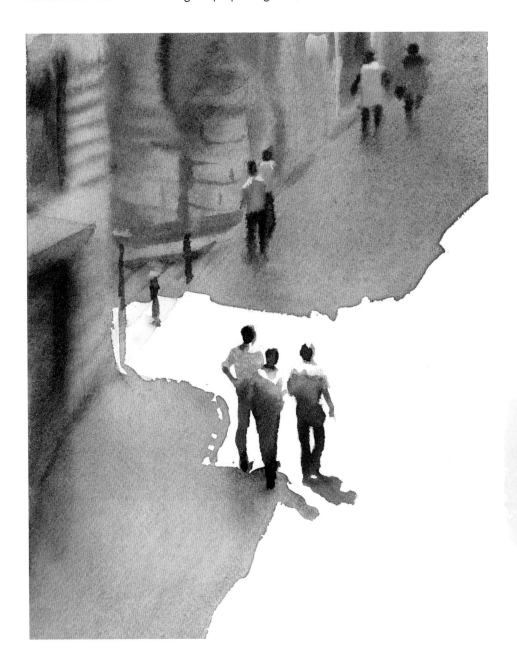

Three Men in the Sun,
28 x 18cm (11 x 7in)
Colourful shadows are created by adding different colours, one after the other, into a wet wash. Here Yellow Ochre is followed by Ultramarine Blue, Raw Umber and lastly Alizarin Crimson, blending together as an attractive variegated wash.

Tonal credibility is clear to see in monochrome, and tonal pattern easier to recognize in the small format. With a digital camera you can quickly check that a painting works well tonally by taking a photo of it in black and white (see page 93).

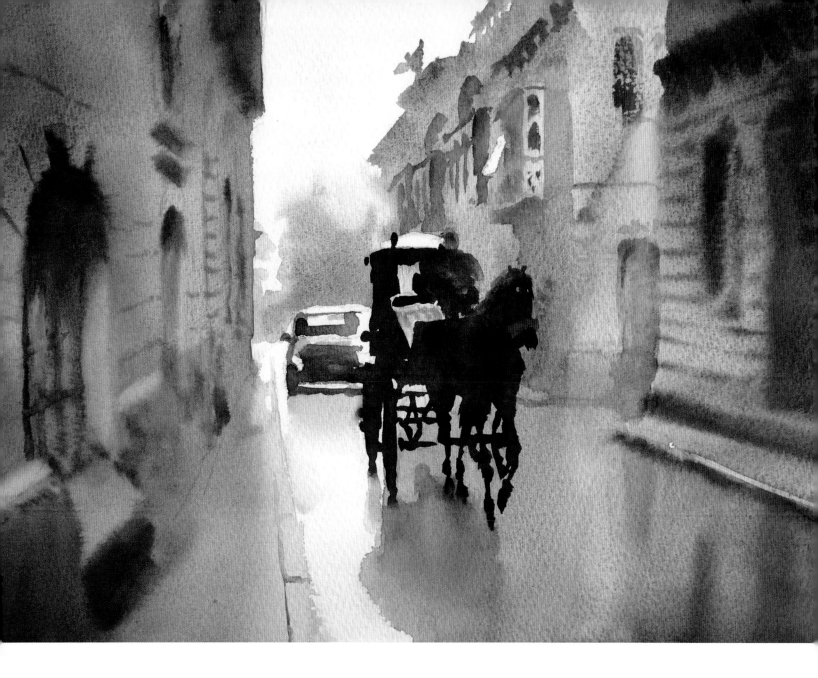

Clean water added into a wet paint can also be used as a way to introduce light or create a backrun so long as the wash is still damp. Once the shadow starts to dry, leave well alone so as not to disturb the drying paint. Resist the temptation to fiddle or try to 'perfect' – you will regret it!

Valletta, Malta, *28 x 38cm (11 x 15in)*
In this picture of Valletta, Malta,
Cadmium Red is used to infuse the shadow in the street with the glow of reflected light from the warm stone of the buildings.

Priming values:
balancing light and shade

The aim of this assignment is to balance your composition in terms of the main light, dark and mid-tone values. Choose a subject with obvious variations in tone and balance the composition by weighing the dominant darks (here the silhouettes and doorways) against the areas of light and mid-tone (here the pavement and background buildings).

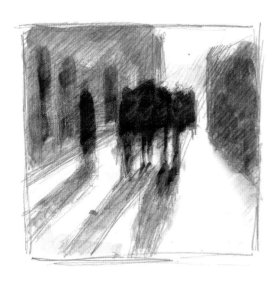

Stage 1: The abstract pattern of light and shade
Make a tonal plan showing the three main values. I jiggled the blocks and bands of the mid- and dark tones with the light tone of the paper until I registered a balance between the triangle of light in the lower right, the area of mid-tone in the upper left, and the central silhouettes.

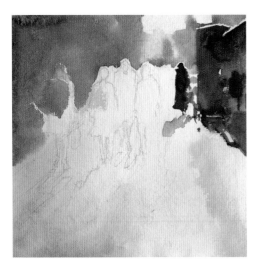

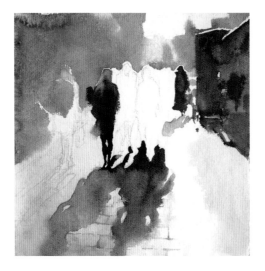

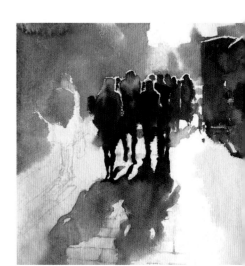

Stage 2
Draw the composition onto the watercolour paper then establish the main tones. I tinted the light with a yellowy wash, then washed in the mid-tone background with the blues and added a distant figure so I could see the full range of tone.

Stage 3
The mid-tone figure shadows were mapped in next, varying the colour with a wet-into-wet blend of Yellow Ochre, Prussian Blue, Violet and Indigo.

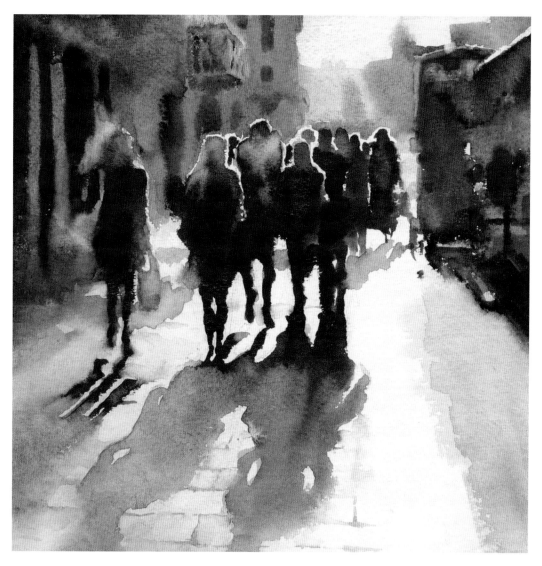

Stage 4

Following the abstract pattern, I painted the figures in equally dark mixes of Indigo and Sepia, relying on perspective to grant the sense of distance. Small, specific counterchanges of light and shade appear between legs, around heads and on shoulders. Heads against the darker background were painted slightly lighter in tone and the heads against the lighter background slightly darker.

Final stage

With the figure on the left and the deep tones of the doorways in place, the overall balance of light and shade was complete. I toned down the light on the lower right with a pale glaze of violet over the yellow.

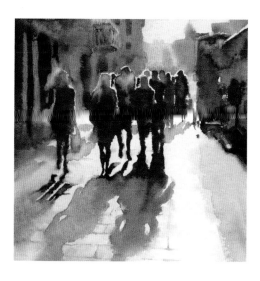

In black and white, without the distraction of colour, you can more clearly see the balance of light and shade in the final painting, which mirrors the balance of the original sketch.

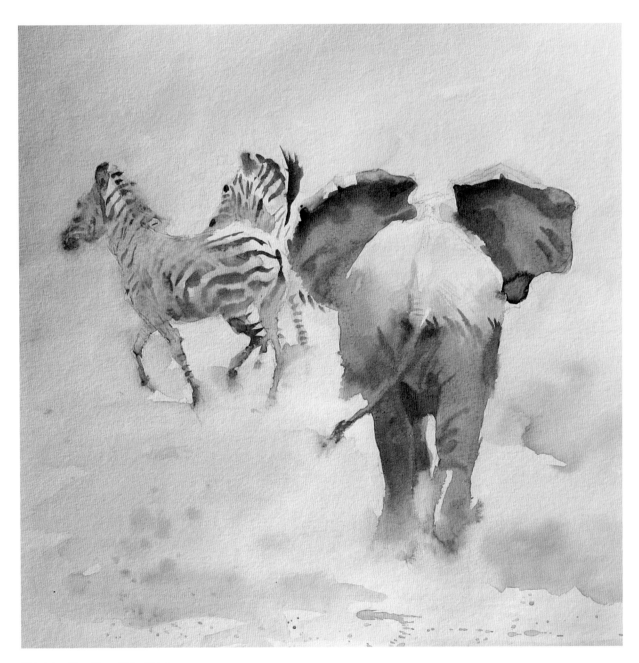

Skittish, 40 x 40cm (16 x 16in)

Embrace Lost and Found Techniques

Balancing detail and suggestion

One of the most appreciated aspects of watercolour is the ability
to create a 'lost and found' appearance across the painting. This visually
stimulating exchange is set up by the contrast between soft suggestive
passages of watercolour and crisply defined marks. The kinetic nature of
watercolour allows pigment to float in water in a way no other medium can
mimic, making the lost-and-found technique possible and delighting the eye
with the play between definition and ambiguity, focus and blur. Here the two
main and aptly named techniques of watercolour work in tandem:
wet-into-wet technique allows 'lost' passages to embrace ambiguity;
wet-on-dry technique defines the boundaries of 'found' brushmarks
and crisp highlights.

Lost: Wet-into-wet Technique

When wet paint is applied to previously dampened paper or brushed into wet paint the technique is termed 'wet-into-wet'. The pigment spreads outwards into the damp area to create a soft graded blend as the particles of pigment disperse or mingle with other particles of paint already on the paper. If the dampened area exceeds the reach of the pigment dispersion there will be no visible edge to the brushmark, hence the 'lost' appearance.

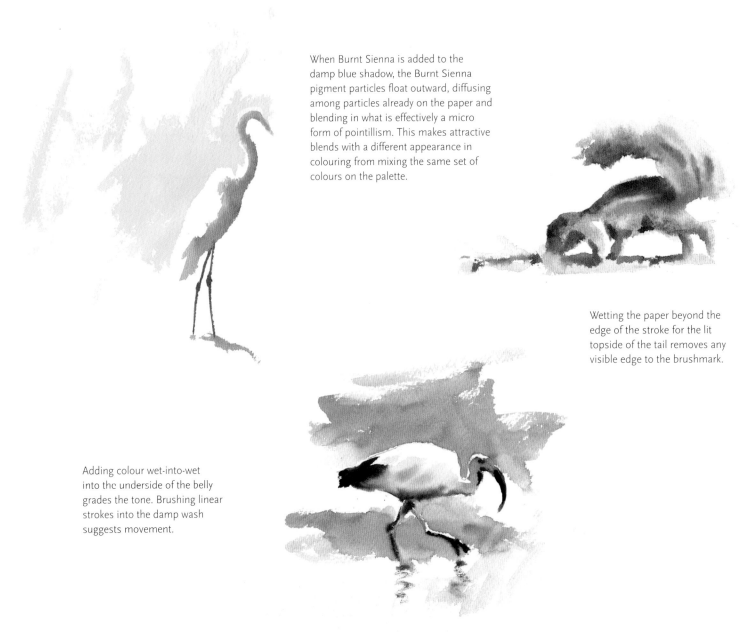

When Burnt Sienna is added to the damp blue shadow, the Burnt Sienna pigment particles float outward, diffusing among particles already on the paper and blending in what is effectively a micro form of pointillism. This makes attractive blends with a different appearance in colouring from mixing the same set of colours on the palette.

Wetting the paper beyond the edge of the stroke for the lit topside of the tail removes any visible edge to the brushmark.

Adding colour wet-into-wet into the underside of the belly grades the tone. Brushing linear strokes into the damp wash suggests movement.

The addition of the blue background before the bird is dry causes minor bleeds, adding a touch of ambiguity to some edges and thus suggesting movement in the bird.

Right Time, Right Mix

The key to successful wet-into-wet application is in timing, and judgement of the right amount of water, both in the paint mix and on the paper. Each subsequent wet-into-wet application adds more water to the paper, so the next brushmark must necessarily be drier than the previous one. If either the brushstroke or the paper is too wet when the next colour is added, the paint will spread uncontrollably. If the paint or paper is too dry, the pigment cannot disperse at all.

Backruns occur (by accident or on purpose) when an overly wet brushstroke is added to a previous wash that has partially dried. The dispersion of the added water backs the pigment up into the already drying paint, where it comes to a halt and settles along a 'cauliflower' edge.

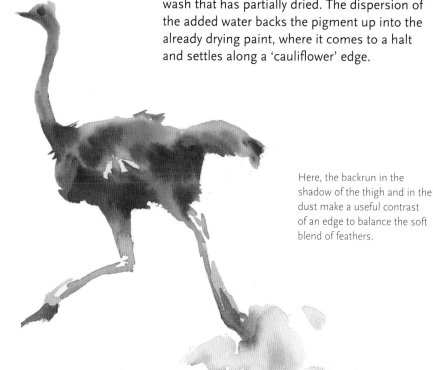

Here, the backrun in the shadow of the thigh and in the dust make a useful contrast of an edge to balance the soft blend of feathers.

Where occasional seedheads overlap on the picture plane the shadows are allowed to bleed into the lights. We have no problem reading these as separate seeds and the ambiguity is attractive.

Found: Wet-on-dry Technique

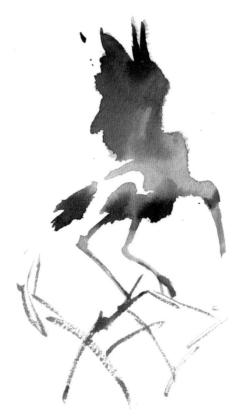

A brushmark laid on dry paper and over dry paint exhibits defined edges, hence it is considered 'found'. The watercolour brush is designed to enable dexterity, allowing a wide variety of brushmarks from broad gesture to precise detail. Thus the edge of a brushstroke can be given a sheer, ragged or broken edge depending on the pressure applied, the angle of the brush, the amount of water in the paint, and the tooth of the paper. This enables a brushmark to be very descriptive and specific.

Practise leaf and petal shapes with a large brush, either round or flat, to gain control of the brushstroke. Try to make the shapes interesting by varying the pressure: more pressure releases more paint, less pressure less paint, creating light and shade within a leaf; alternating the pressure on either side of the brush head creates attractive 'ragged' edges.

Solid edge/ragged edge. Brushmarks for an area, such as in the wing of this yellow-billed stork, should be made with as few joined-up stokes as possible. Ragged edges and lines are delivered from the side of the brush rather than the tip.

Flower petals and leaves are ideal for practising interesting positive and negative brushstrokes.

Practise negative shapes by outlining a complex shape, such as a white flower, within a single smooth wash.

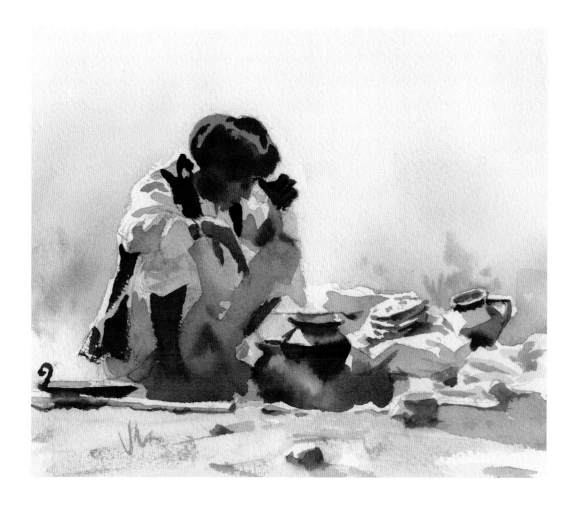

Desert Fare,
23 x 28cm (9 x 11in)
Although this is a small painting, the same large round sable brush was used to paint both the specific shapes of the hands, pots and poppadoms and the less distinct areas in shadow.

Brushwork Dexterity

With the aim of using as few strokes as you can to lay the desired passage or shape, choose the largest size of brush possible for the wash or mark intended. Use the whole body from tip to ferrule, laying broad marks from the side of the brush, solid edges from the tip, and ragged edges from the heel. The fewer joined-up strokes you make to describe a shape or lay a wash, the more happily the pigment particles will settle in the passages of watercolour.

Load the brush fully in the palette, rather than just using the tip; roll the brush head in the paint mix until the brush is full of paint, using this motion to shape the tip to a point.

Brushmarks are the handwriting of the artist and cannot lie! Lay them with confidence rather than hesitancy. I have a motto: 'If in doubt, chicken out!'

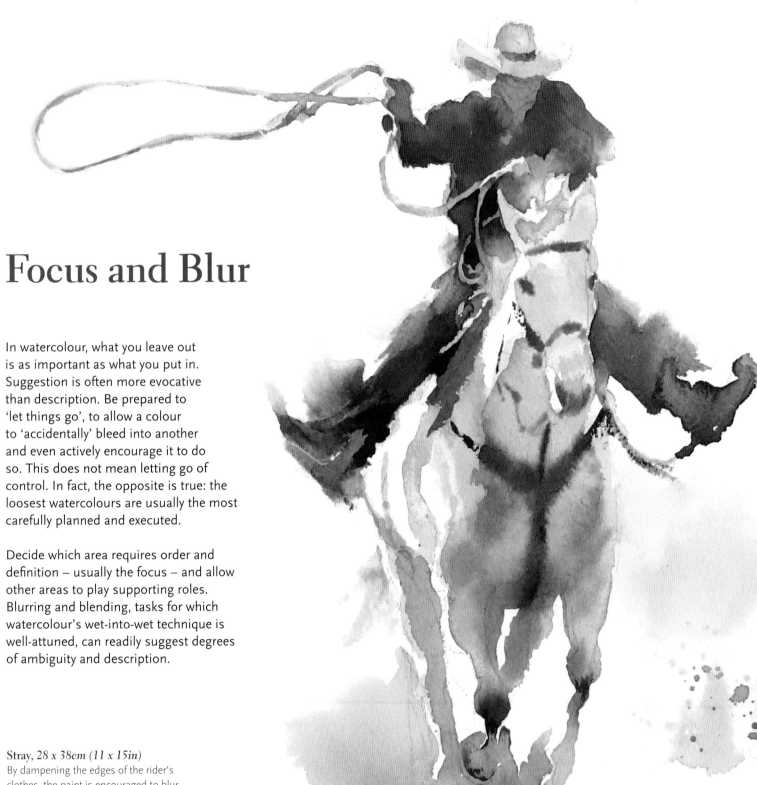

Focus and Blur

In watercolour, what you leave out is as important as what you put in. Suggestion is often more evocative than description. Be prepared to 'let things go', to allow a colour to 'accidentally' bleed into another and even actively encourage it to do so. This does not mean letting go of control. In fact, the opposite is true: the loosest watercolours are usually the most carefully planned and executed.

Decide which area requires order and definition – usually the focus – and allow other areas to play supporting roles. Blurring and blending, tasks for which watercolour's wet-into-wet technique is well-attuned, can readily suggest degrees of ambiguity and description.

Stray, *28 x 38cm (11 x 15in)*
By dampening the edges of the rider's clothes, the paint is encouraged to blur, enhancing the impression of speed.

'Fail to prepare; prepare to fail.'

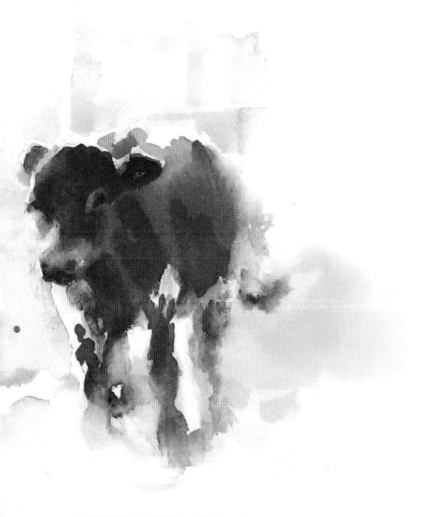

Large wet-into-wet passages require planning and concentration: be ready with big brushes, plenty of colour and clean water. Brook no interruption – turn your phone off! The concentration required to lay a large, ambiguous passage of several blending colours in a manner resonant with meaning can be surprisingly intense. It can be quite an adrenaline rush. Look ahead for 'breathing places' in the composition where the wash can be safely brought to a halt without a seam; the edge of a highlighted area or a dark proximity shadow are good places to regroup, calm the nerves and refuel the paint mix.

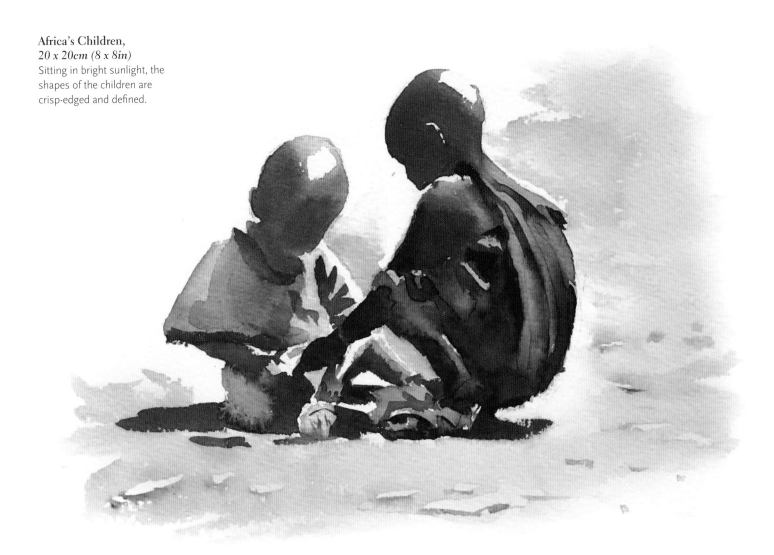

Africa's Children,
20 x 20cm (8 x 8in)
Sitting in bright sunlight, the shapes of the children are crisp-edged and defined.

Definition in the Light

Definition is generally found in the lit areas of a composition and lost in the shadows. With this in mind, keep highlights crisp and light mid-toned areas well-defined. Wet-on-dry brushstrokes give sharp edges to the shapes and emphasize descriptive detail. They also draw the eye, making them perfect for focal objects or figures.

Ambiguity in the Shade

Ambiguity and suggestion inhabit the shadows, where items meet and merge as detail is obscured by shade. Areas in shadow can therefore be softened with blur or blended wet-into-wet as linked passages of intermingling colour. Hints of descriptive elements can be touched into a blended shadow wash, wet-into-wet, using a fine brush to deepen the tone. Similarly, lighter-toned elements can be gently lifted out with a fine brush while the wash is damp or with more precision when the wash is dry.

The paper is only dampened where blending is required; areas of definition remain dry. Wet the paper as evenly as possible, ideally with a large flat brush because it delivers an even flow.

Paper buckles readily when wet, causing paint to pool in valleys, making it hard to control the flow. Heavyweight paper (such as 400–600gm), pre-stretched paper and paper stuck or taped around all four sides is much less likely to buckle. Avoid dabbing a wet or drying wash or you will disturb the natural and attractive settling of the particles of pigments on paper.

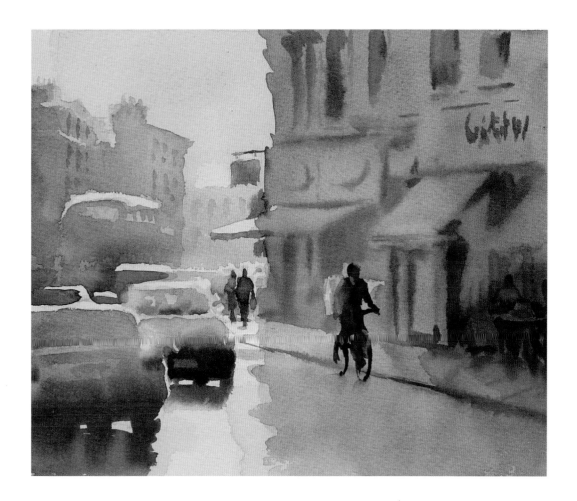

Rush Hour, Fulham Road, London, 23 x 28cm (9 x 11in)
This rendition of a London street is created from a range of mid-tone values activated by highlights and dark accents. Underwashes of Ultramarine Blue, with Alizarin Crimson and Burnt Sienna, map in the main blocks of tone, while impressions of details, such as doors and windows, are added wet-into-wet.

Lost and found: focus and blur

Look back through the paintings in this book for combinations of wet-on-dry and wet-into-wet techniques where they have been used in a lost-and-found, or focus-and-blur fashion. Look at whole compositions as well as details.

Go out into the landscape and paint a series of watercolours of a similar theme so that you become familiar with your subject. Simplify the composition into a few main areas of tone and colour. Dampen the paper with a pale sky wash to soften the foliage forms as you brush them in, wet-into-wet, and add the tree trunks just as the paint dries, so that in some areas the brushstrokes bleed a little into the background wash, and in others they are crisply defined, wet-on-dry. Learn the drying time of your paper on this day, note humidity, and how wind and sun speed up drying.

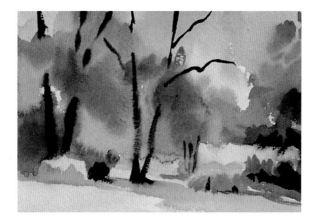
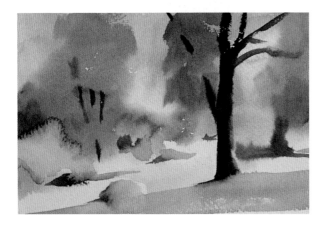
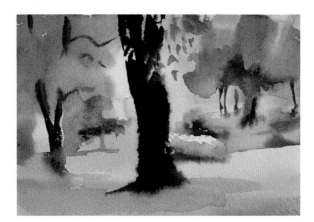

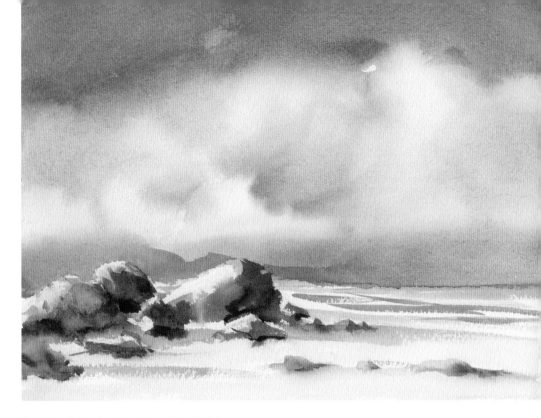

Next find a subject with more defined form, like this beach scene, with features in the foreground. Paint descriptively but loosely, allowing some bleed to occur across pencil lines and contours. Here, for example, I have encouraged some ambiguity between the rocks and in the distance.

Longbeach Rocks, *28 x 38cm (11 x 15in)*

As your confidence grows, find subjects that are more complicated, such as these figures on the promenade in Portovenere, Italy. Draw the main shapes carefully enough to give yourself confidence to let the paint go, and blend features of similar tone together without fear of losing narrative. Apply paint with large flat or round brushes, and allow the paint to disperse across lines into damp washes.

DISCOVER

How much you can 'let paint go' without losing definition and how much the lack of distinction adds to the life and energy in the painting.

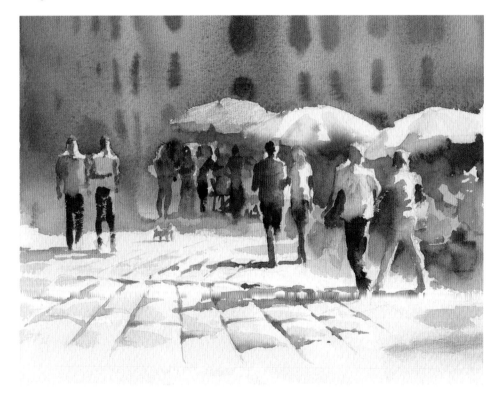

Figures on the Promenade, Portovenere, Italy, *18 x 28cm (7 x 11in)*

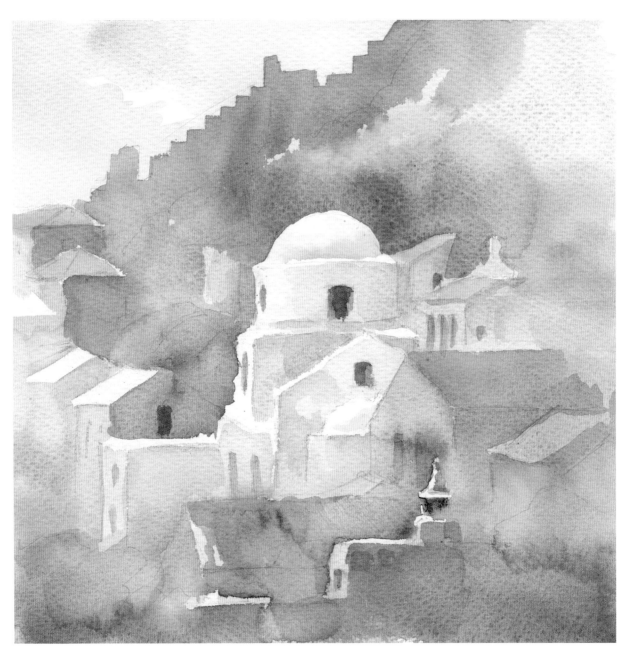

The White Church of Panagia Myrtidiotissa, Monemvasia, Greece,
30 x 28cm (12 x 11in)

CHAPTER 8

Evoke Atmosphere

The power of light and shade to create atmospheric effects

Watercolour is celebrated for its ability to evoke ambience and atmosphere. Its translucent washes offer a unique illumination and glowing light and opaque pigments suggest misty horizons. The ease with which water can blur detail and soften edges can readily create haze and raise dust. Shadows resonate with intriguing mystery as blended passages of alternating colours and gentle gradations of tone suggest hidden features obscured from light. All these characteristics make watercolour a masterful medium for painting atmospheric effects.

Atmospheric Effects

When a watercolour is termed 'atmospheric', wet-into-wet blending is usually involved. The inherent mystery of a blend, changing in colour or tone within a single wash, is visually immeasurable and therefore intriguing. Softening the key, using colour temperature, granulation, opacity, lack of definition and a predominance of shade all help to create an atmospheric appearance in a watercolour. And because definition is naturally lost in mist, haze and shadow, watery and dusty settings and backlit views are the more likely subjects to offer opportunities for atmospheric effects.

Lake Pichola, Udaipur, India,
25 x 35cm (10 x 14in)
The hazy horizon is rendered with a graduated wash of Ultramarine Blue, diluted to a pale tone at the water's edge.

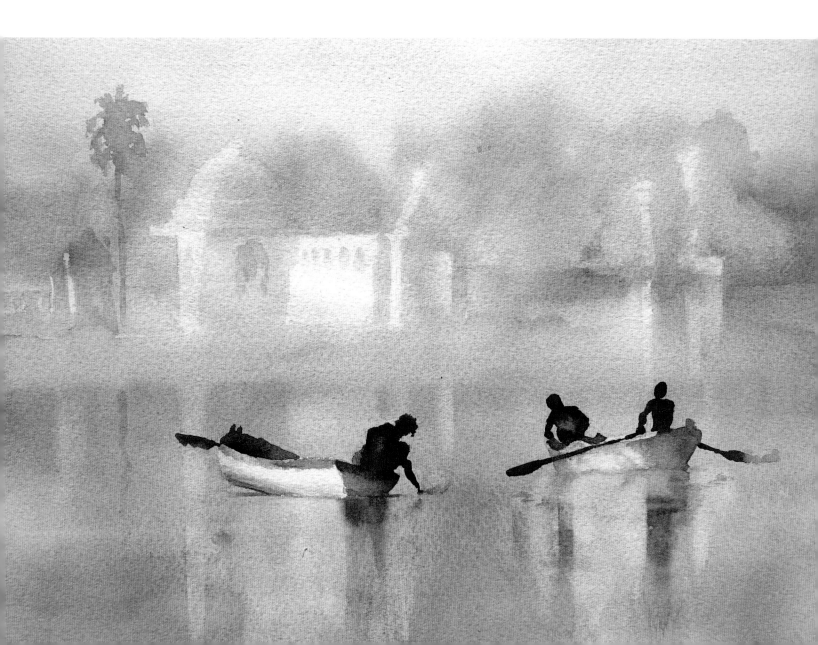

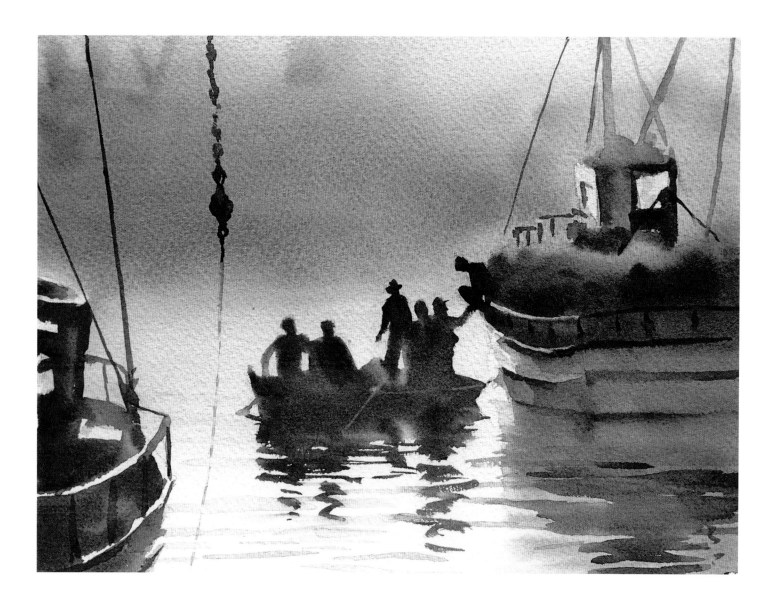

Infusion of Light

Glowing illumination is created with washes of warm transparent yellows and misty atmosphere softened with opaque and semi-opaque hues. I often employ underwashes of Yellow Ochre or Indian Yellow to create the ambience of golden light in hot, dry terrains and Aureolin for cooler, damper climes. Darker tones and descriptive detail are then added on top. Illumination is amplified by the light reflected back through translucent washes so a minimum of layering is essential.

Luz, Luderitz, Namibia,
25 x 35cm (10 x 14in)
A variegated wash creates the misty atmosphere of early morning. The paper is wetted all over and then brushed with Yellow Ochre, Burnt Sienna, Burnt Umber and Ultramarine Blue, suggesting a vague harbour backdrop.

Intriguing Passages and Beguiling Shadows

Several different colours blended together in a single wash form a variegated wash, giving an intriguing appearance to a passage of watercolour. In similar fashion, varying a shadow with a gentle gradation of tone or colour creates a more beguiling effect than just laying the shadow in a single colour and tone. Infiltrating backlit shadows with hints of colour and illumination suggests vapour in the air or filtered sunlight, and therefore enhances a sense of atmosphere.

Smoke on the Hills of Lesotho,
28 x 38cm (11 x 15in)
Moody skies and lowering clouds offer the chance of a variegated wash in the sky, bringing a sense of atmosphere. Note how the figures are positioned dark against light in front of the smoking fire. This draws our attention.

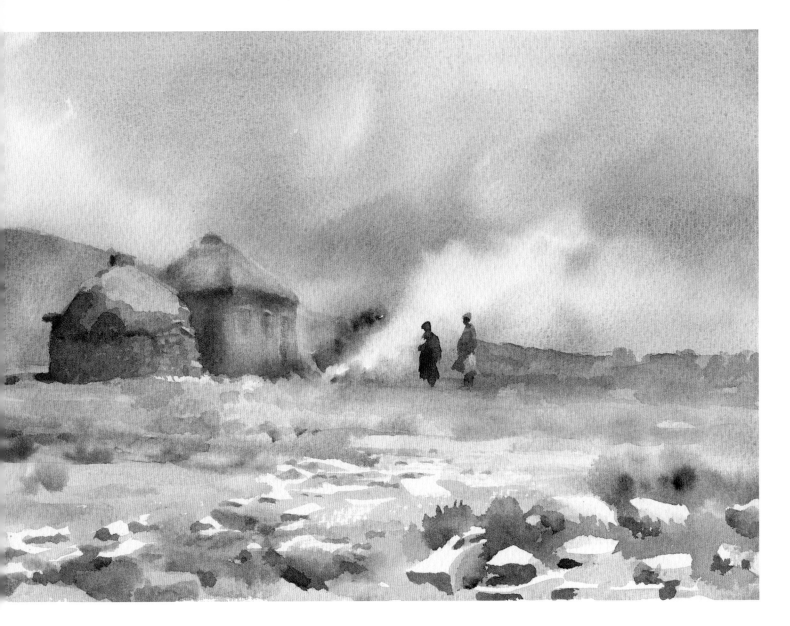

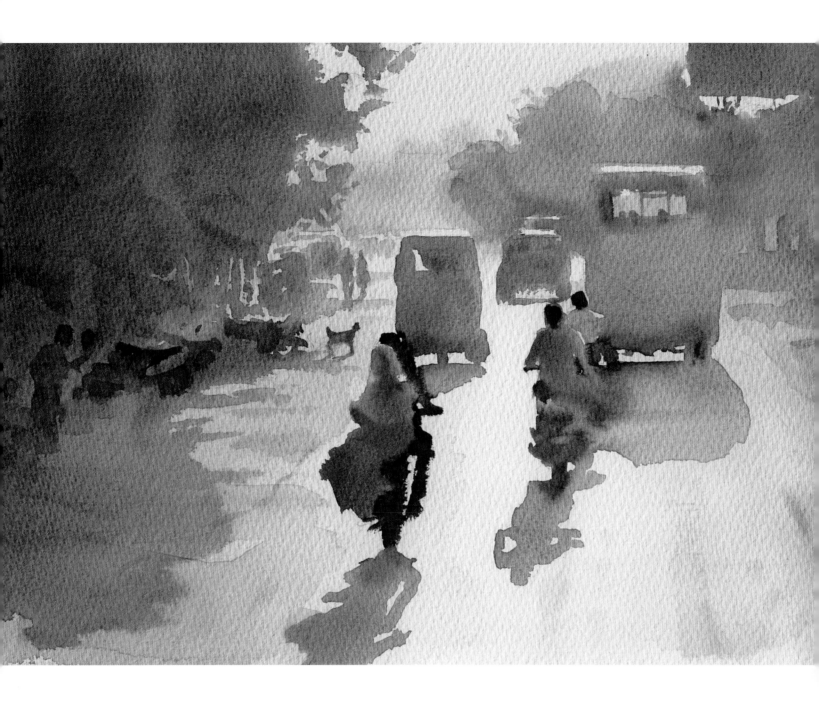

Indian Highway,
28 x 38cm (11 x 15in)
The intriguing light emanating from
this backlit street is enhanced by adding
Indian Yellow into the shadowy shapes
of vehicles and trees.

There are several ways to introduce lighter tone to shadow: clear water or opaque
colour can be touched into the dark shadow while it is still damp or the paint mix
can be lightened by further dilution in the palette as it is laid.

The wash can be deepened or given more colours by adding more pigment into the
wash while it is damp. Pre-wetting the area before laying the shadow encourages a
soft blend.

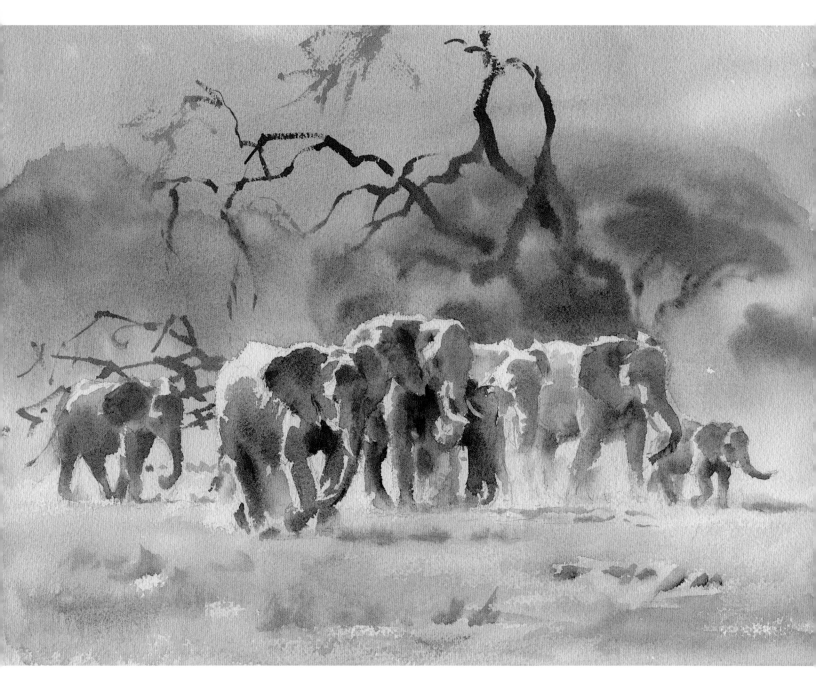

Savannah, 30 x 40cm (12 x 16in)
For this scene, the background and foreground colouring was brushed in from top and bottom over dampened paper. The areas blend, leaving a pale area in the middle to represent the dust stirred up by the elephants ambling by.

Mist, Haze, Dust

Hazy background mists and dusty horizons are created by wetting the paper horizontally across the picture plane and allowing background and foreground colours to run into but not meet across the damped area, creating a paler area in between. Opaque yellows, blues, browns and violets present a mistier appearance than their transparent counterparts. Light Red, Yellow Ochre and Cobalt Blue are colours I may use to suggest haze. Chinese White (Zinc White) can be added wet-into-wet to lighten a distant horizon or painted wet-on-dry to veil a colour to send it further into the distance. When a pale tone at the horizon or at the base of a building is offset by darker tone, such as silhouette figures, it will appear lighter by contrast.

Kraal, Olduvai, Tanzania,
25 x 35cm (10 x 14in)
The trace of dust behind the figure here is created by dampening the area and lightening the tone of the kraal fence where it is veiled in dust.

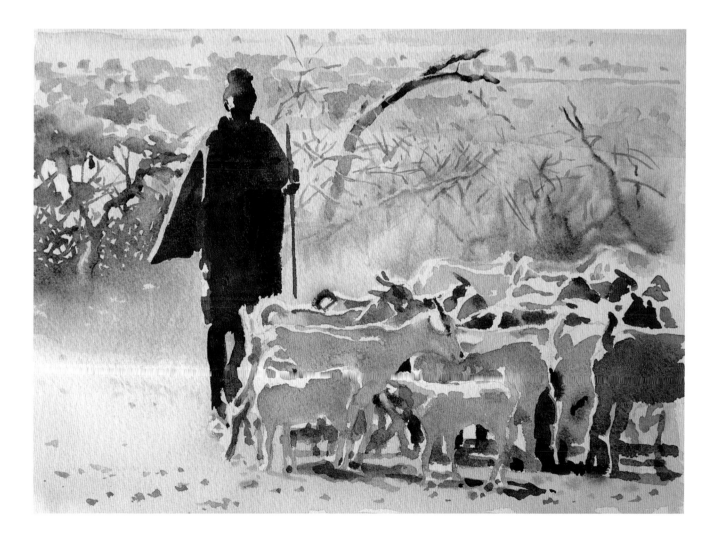

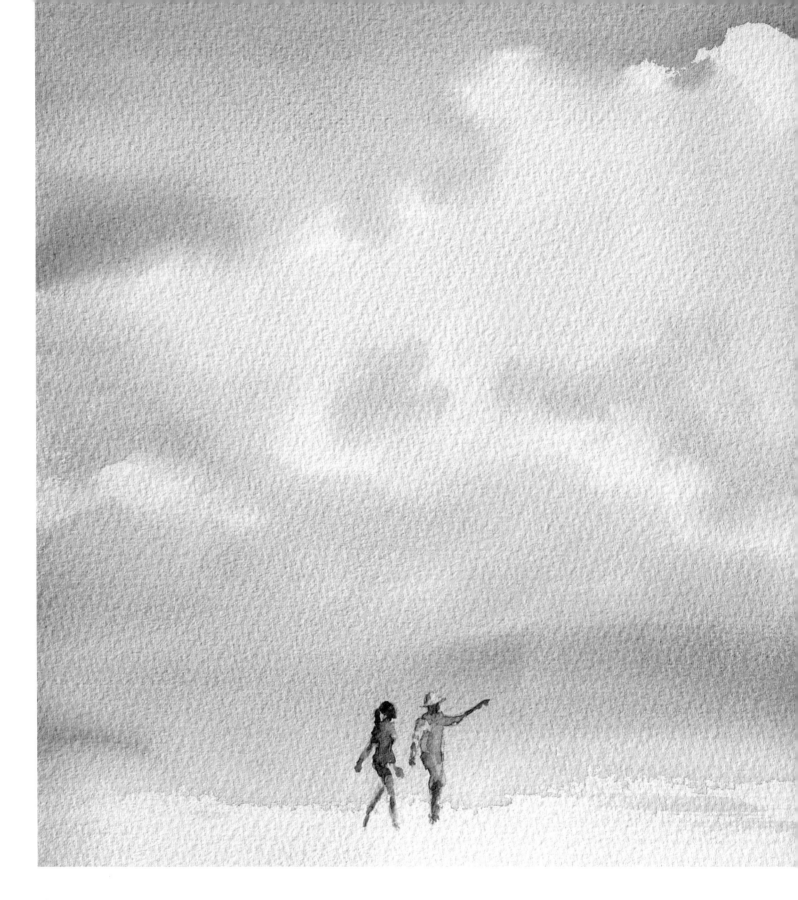

'Fear is temporary, regret is forever.'

Mists of the Southern Ocean
28 x 38cm (11 x 15in)
The dark accents of the figures in
this scene emphasize the pale, misty
appearance of the Cape Peninsula
lost in low cloud.

Granulation

Some pigments have sedimentary tendencies which cause the pigment particles to settle unevenly in the tooth of the paper. The earth colours and some metal colours, i.e. the larger-pigment particles, are prone to this tendency, which creates an attractive granulated texture and enhances atmosphere in a watercolour. Granulating colours include French Ultramarine, Cobalt Blue, Oxide of Chromium, Raw Umber and Brown Ochre.

Wild Earth Colours, *56 x 76in (22 x 30in)*
The granulating properties of Raw Sienna and Cobalt Blue contribute to the feral earthy atmosphere in this group of lionesses.

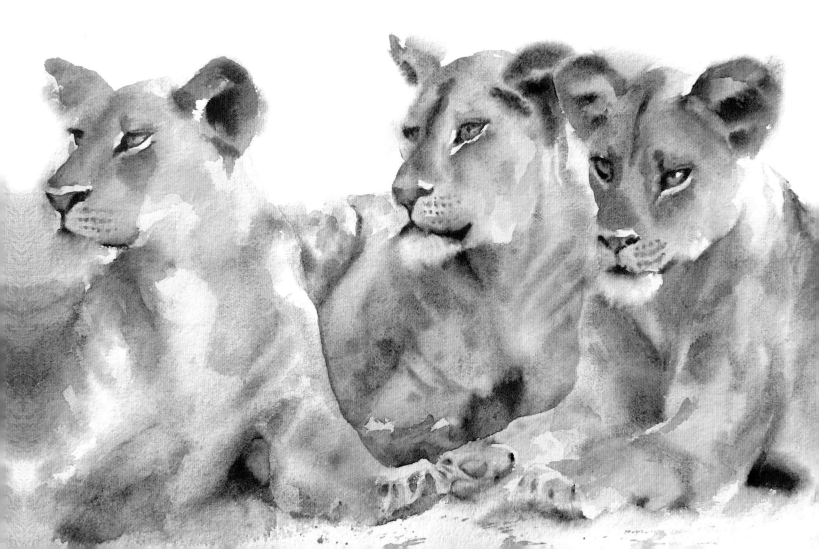

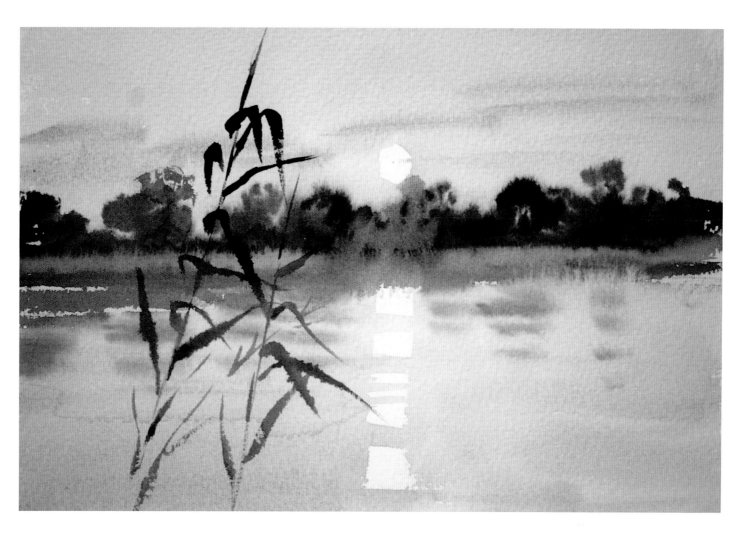

Okavango Dawn,
18 x 28cm (7 x 11in)
The calm mood on this river at dawn
is created in the watercolour with
cool colours and simple, non-fussy
brushstrokes. Less is more!

Mood

Mood is a difficult thing to assess, let alone write about, but it
is basically atmosphere created by colour temperature and tonal
bias. Red is cheerful, blue is calm. Bright, strong and dark colours
are dynamic, powerful and serious, whereas a lighter key presents
a gentler, light-hearted mood. Two paintings of the same subject,
under similar light, can thus be made to present completely
different moods by using alternative colour sets, as shown in
the examples overleaf.

Exploring atmosphere with colour

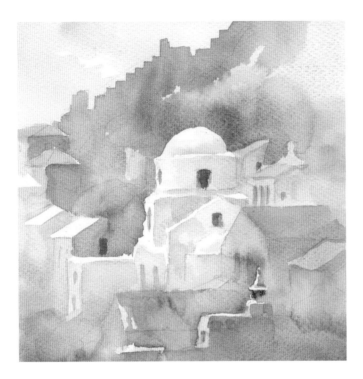

Paint the same subject several times using different colour sets and include granulating colours. If you find a particular set pleasing, paint the subject again, in a looser fashion, using the same colours, and try to catch the essence of the subject with a minimum of description.

I chose an enchanting view of the white church, Panagia Myrtidiotissa, in the fortified medieval town of Monemvasia in Greece. I painted the same subject in both morning and afternoon light, creating different atmospheric effects with different sets of colours.

Indian Yellow, Cobalt Blue, Raw Umber, Burnt Umber and Cadmium Red are combined here in the first painting, which I made in the early morning. Gentle granulation has occurred within the lost-and-found technique.

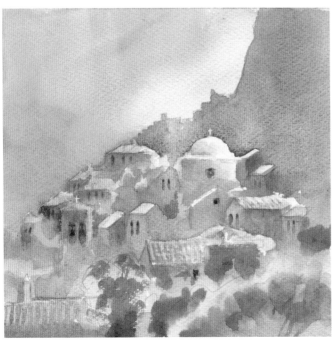

In this rendition in afternoon light, I chose three granulating colours: Raw Sienna for my 'yellow', Cobalt Blue for my 'blue' and Cobalt Violet for my 'red'. All three colours granulate, creating a pleasing texture and a warm atmosphere.

DISCOVER

Painting the same subject several times is a surefire way of learning to see and paint light and shade. You become familiar with the patterns, recognizing which tonal exchanges and details are important to include, and which can be ignored or combined.

I repeated the Raw Sienna, Cobalt Blue and Cobalt Violet combination, loosening the composition to basic essentials (a good plan since the light was disappearing fast behind the rock!), thereby creating a more ethereal evocation.

In the final afternoon view (see also page 102) the sky was cloudy and the light rather flat, but by now I 'knew' the view, knew the main structure of the composition and was familiar with the predominant pattern of light and shade, and, above all, knew what interested me to paint. I used Indian Yellow to create glow on the white church, Prussian Blue to keep the colour temperature cool, and Burnt Umber and Light Red for the granulation. Familiarity with the subject enabled a strong painting to emerge from a dull light.

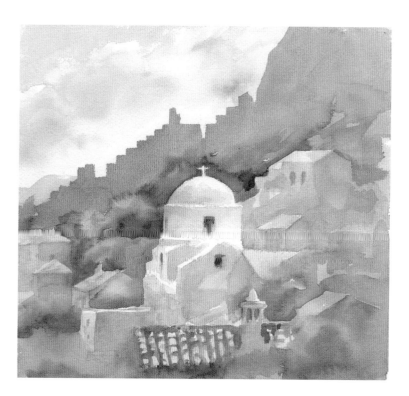

The White Church of Panagia Myrtidiotissa, Monemvasia, Greece, 28 x 30cm (11 x 12in)

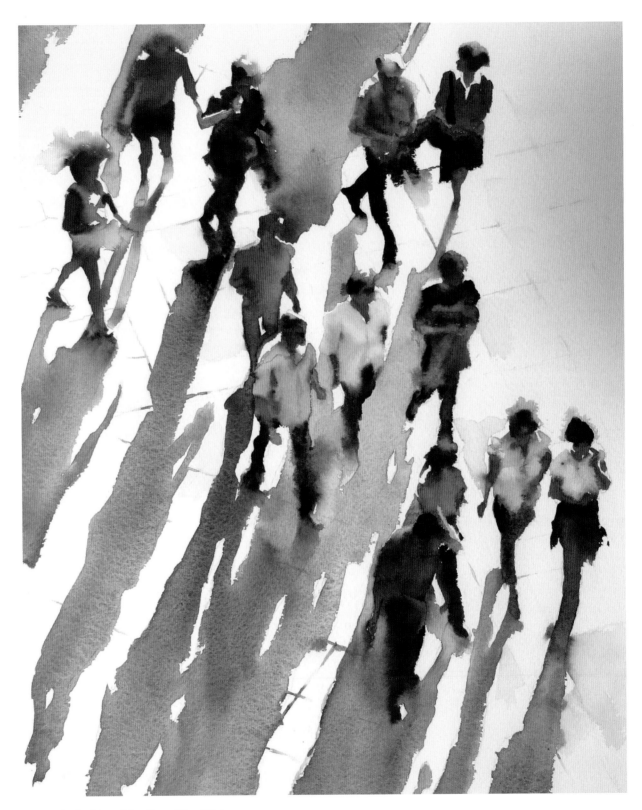

Forward Thinking, 56 x 43cm (22 x 17in)

CHAPTER 9

Find Patterns

Patterns of light and shade to look out for in specific subjects

The paintings on the following pages suggest some of the different patterns of light and shade to look out for when painting similar subjects. Everything depends on the light. Any subject makes a good painting if it has an interesting pattern of light and shade playing across the composition.

Movement and Action

Watercolour is ideal for portraying movement and action because it is itself a kinetic medium. Pigment particles are moved around by water on the paper to cultivate blends and foster bleed. Exciting ambiguity in the lights and shades can be encouraged by dampening paper before a brushstroke is laid or by adding water beside or into an already laid mark and encouraging it to spread.

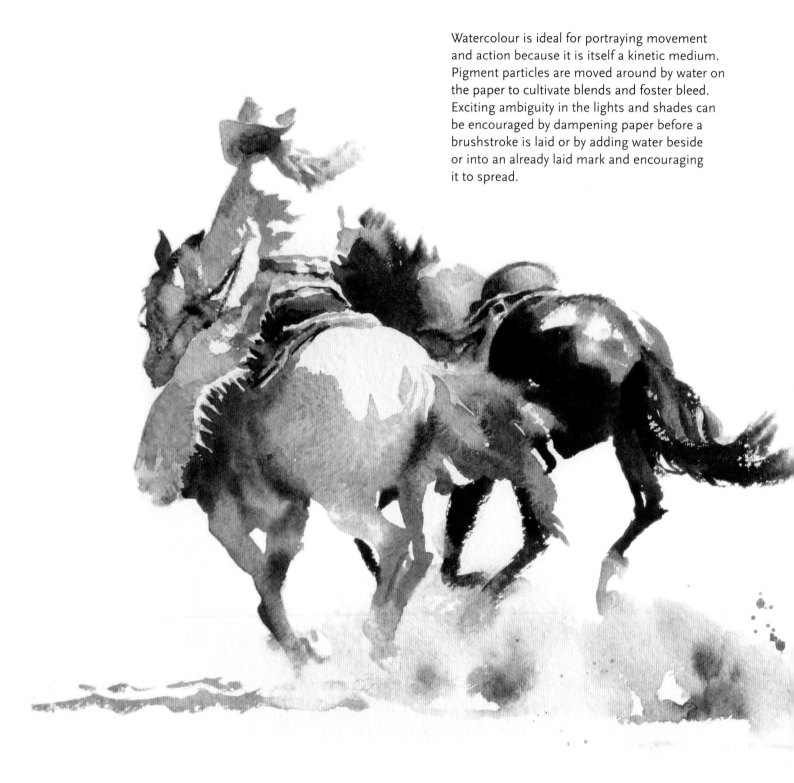

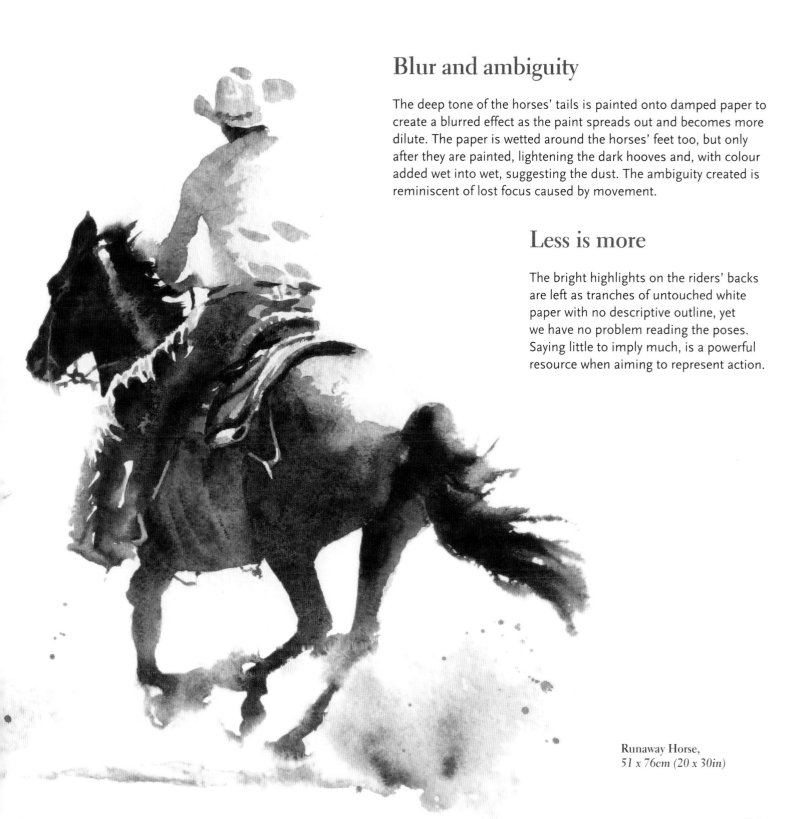

Blur and ambiguity

The deep tone of the horses' tails is painted onto damped paper to create a blurred effect as the paint spreads out and becomes more dilute. The paper is wetted around the horses' feet too, but only after they are painted, lightening the dark hooves and, with colour added wet into wet, suggesting the dust. The ambiguity created is reminiscent of lost focus caused by movement.

Less is more

The bright highlights on the riders' backs are left as tranches of untouched white paper with no descriptive outline, yet we have no problem reading the poses. Saying little to imply much, is a powerful resource when aiming to represent action.

Runaway Horse,
51 x 76cm (20 x 30in)

Fabric and Clothing

Clothing and fabric are marvellous compositional devices for exploring patterns of light and shade because folds and creases provide a swift counterchange between light and dark tones. Loose fabric readily demonstrates movement and clothing brings with it the benefit of vivid colours and contrast.

Form suggested by highlight and shadow

The exchange of light and shade playing across draped fabric creates patterns of highlights and shadows, especially among folds and creases, meaning that with very little actual description you can suggest the form beneath the fabric and movement of the pose.

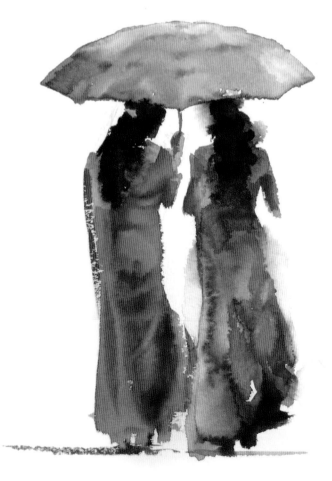

Conversations in Colour (Sari Girls), 20 x 20cm (8 x 8in)

An excuse for colour

With fabrics and clothing comes
an abundance of colour. Keep
everything in harmony.

Ring of Red,
76 x 56cm (30 x 22in)

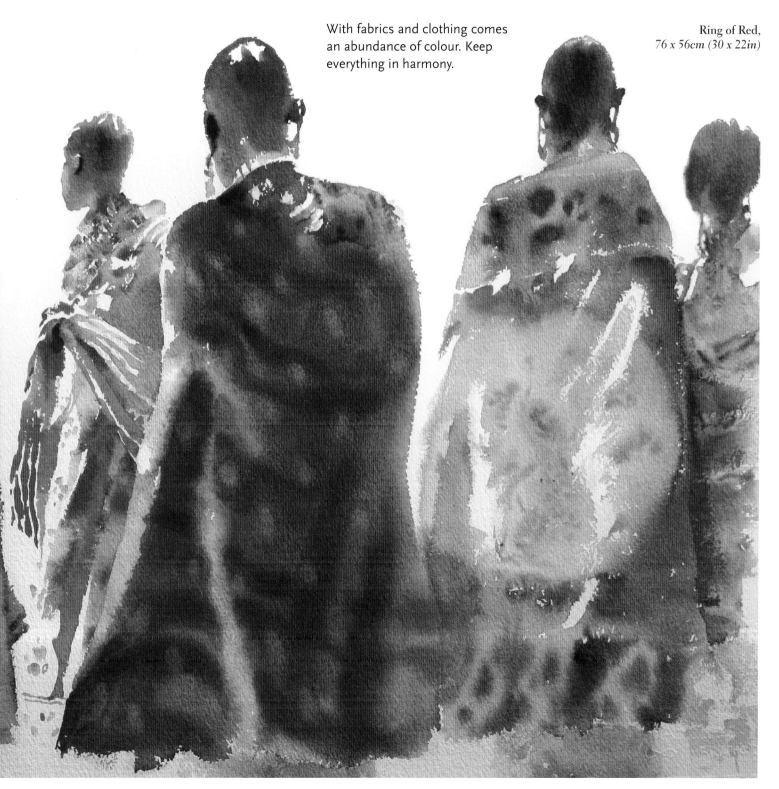

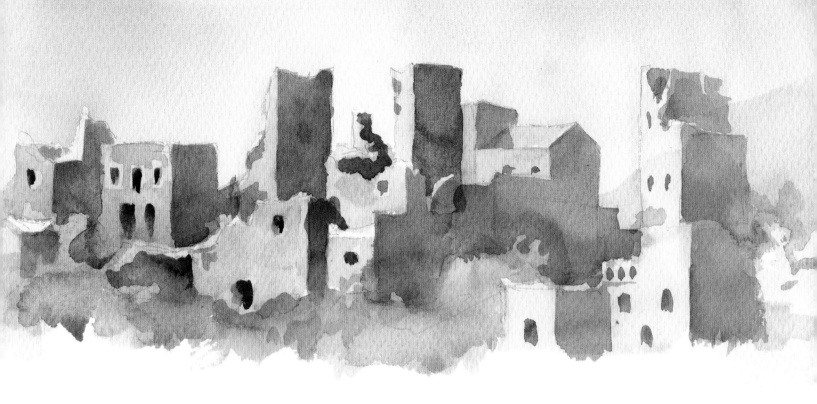

Architecture

Tower Houses, Vatheia, Greece,
15 x 38cm (6 x 15in)

Architectural subjects offer geometry and the joy of faceted arrangements displaying different tonal values. With this inherent contrast of tone, these subjects are pretty much guaranteed to make exciting paintings!

Planes and angles

Note where the light is coming from – which planes are angled towards the light and which face away. If relative tone becomes confusing you can fall back on this logic. (See also the assignment on pages 64–65.)

Definition and suggestion

Wet-on-dry technique enables the crisp, hard edges to buildings but this does not mean you cannot lose some areas in shadow. Nor do you need to define, or even show, every window and door. Leave some details to the imagination of the viewer.

Floating, Symi, Greece,
30 x 40cm (12 x 16in)

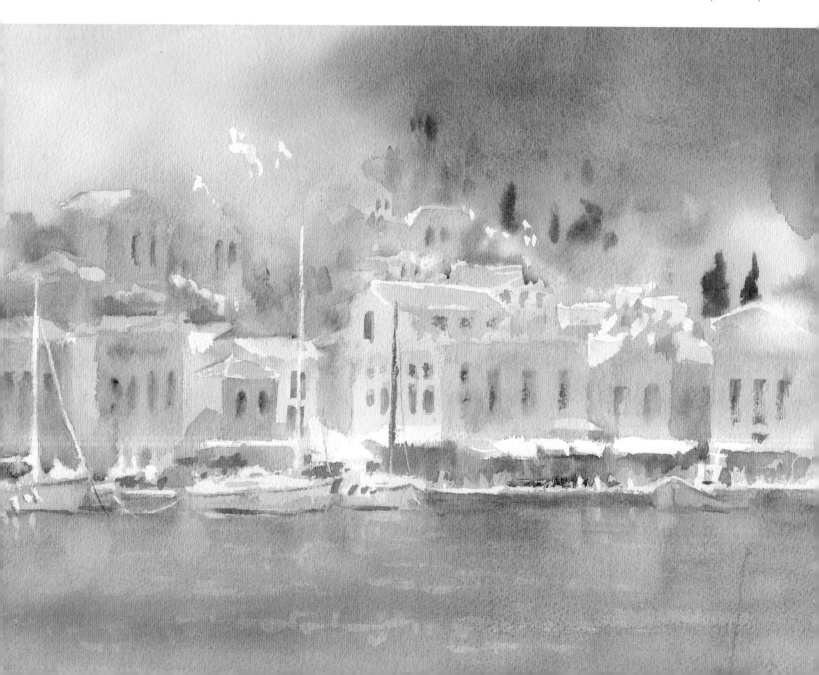

Figure Groups

In art, the intervals between things matter just as much as the things themselves: in music the spaces between the notes are integral to the sound; in theatre the silence between words is crucial to the narrative. Likewise in visual art, the spaces between objects are as 'positive' as the objects themselves, even though in art terms they are referred to as the 'negative' spaces. The arena of the watercolourist is the flat, two-dimensional plane of the paper. Thus it follows that any marks made on the paper and the spaces between those marks are of equal importance to the overall design of the picture.

Repetition

Repetition is a strong compositional device used by artists and musicians alike. Paintings are patterns of colours and shapes that interlace upon a common ground and there is harmony in the recurring colours or forms that dance across a picture plane.

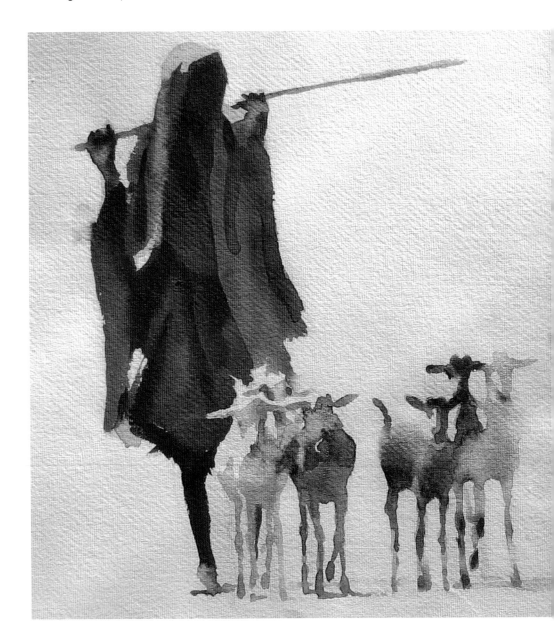

Camaraderie,
30 x 66cm (12 x 26in)

Interval

The shapes of the spaces between the figures are as important as the figures themselves. In the painting below, each figure covers almost the same area but is a different shape. And each figure is almost the same height and build.

The dialogue between the positive and negative 'spaces' keeps the composition in balance and in this respect they are a duality, like light and shade, yin and yang.

Tonal range within one colour

Plain fabrics offer a marvellous opportunity to explore the range of tones with a single hue. Clothed in their traditional blankets, this group of Maasai herders display a range of different reds. Cadmium and Quinacridone Red provided the basic local colour and Alizarin Crimson, Brown Madder and Violet gave me the deeper colours for the creases within folds.

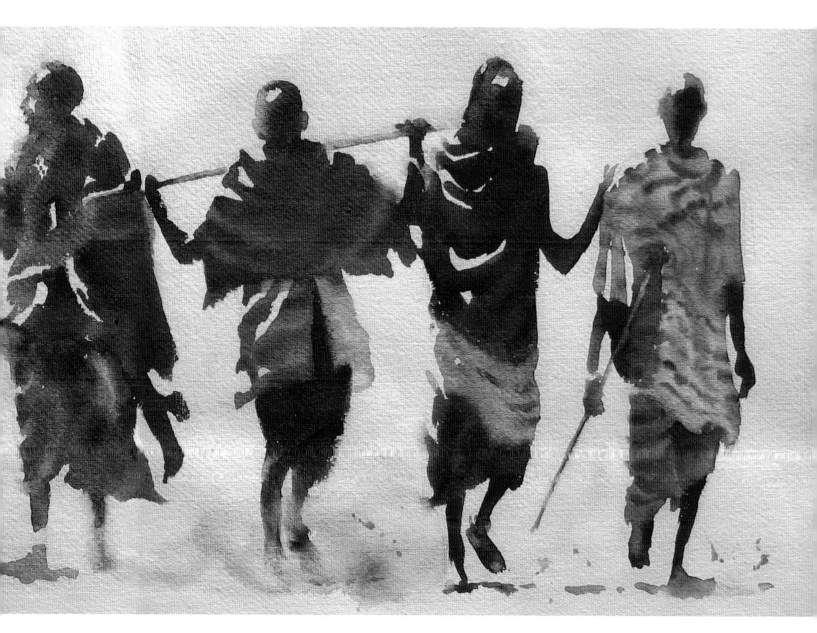

Figure Portraits

Dancer in Waiting
40 x 30cm (16 x 12in)

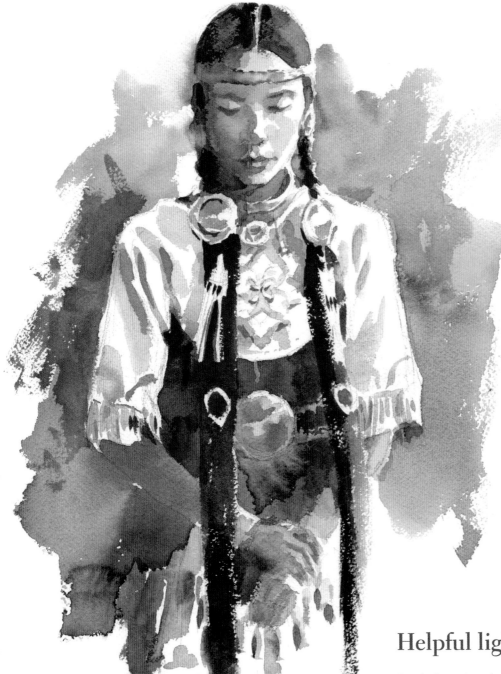

Likeness can be found in a pose as much as in the face. When painting a likeness, concentrate on the structure of the face rather than the features; look for the shadows under eyebrows, under the lower lip and chin, and cast by the nose. Look for the distances between each facial (or bodily) feature; likeness is usually found more in the arrangement of the features than in the features themselves.

Helpful lighting

A side-lit rather than front-lit view is advantageous in that one side of the face is darker in tone than the other, giving you a useful contrast of tone from the start.

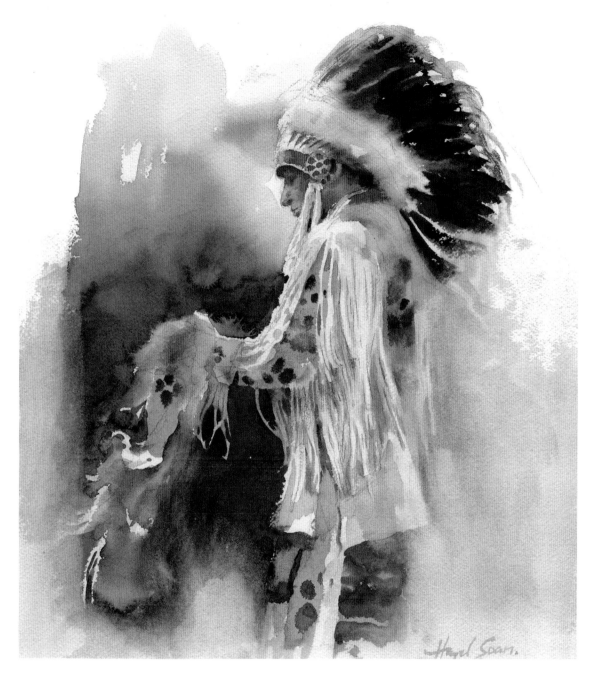

Profiles

Profiles are often easier to manage than front or three-quarter views and just as descriptive. Try not looking down at your paper while you draw the contour of a profile from forehead to chin – it may turn out to be more interesting and more accurate than if you keep looking down.

Chief of the Blackfoot
30 x 25cm (12 x 10in)

Wildlife

The flowing organic nature of watercolour is made for painting wildlife – loose brushstrokes and blurred edges animate wild creatures so they almost leap from the page! Form and detail can be implied by facilitating wet-into-wet techniques to manage the transitional tones and describe the surface texture. The earthy colours of camouflage can be painted with actual earth pigments and enlivened with brighter hues without the danger of looking false or garish. No wonder I love this medium for painting in the African bush!

Stealth, 102 x 46cm (40 x 18in)
The overall shape of the leopard is as important as the detail within the shape. But the contours themselves need not be defined, as blur helps movement.

Form and texture combined in one brushstroke

The leopard's markings are painted with Sepia and tinted with Burnt Sienna and Translucent Orange. Sepia is a slow-moving pigment, which therefore retains the shape of each spot as it is touched in 'wet-into-wet' as long as the paper is not too damp or the Sepia too runny. Note the shapes and tones of the spots – round when seen from the front, elliptical on the sides, pale in lit areas, dark in shadows – therefore each mark serves to describe both form and surface pattern.

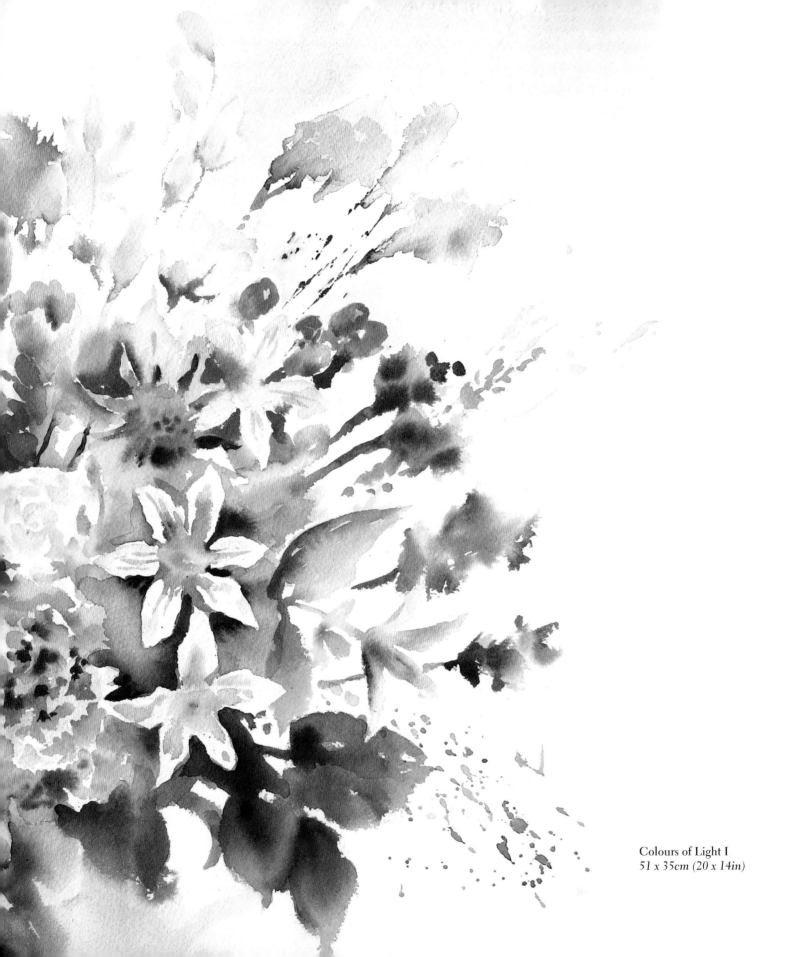

Colours of Light I
51 x 35cm (20 x 14in)

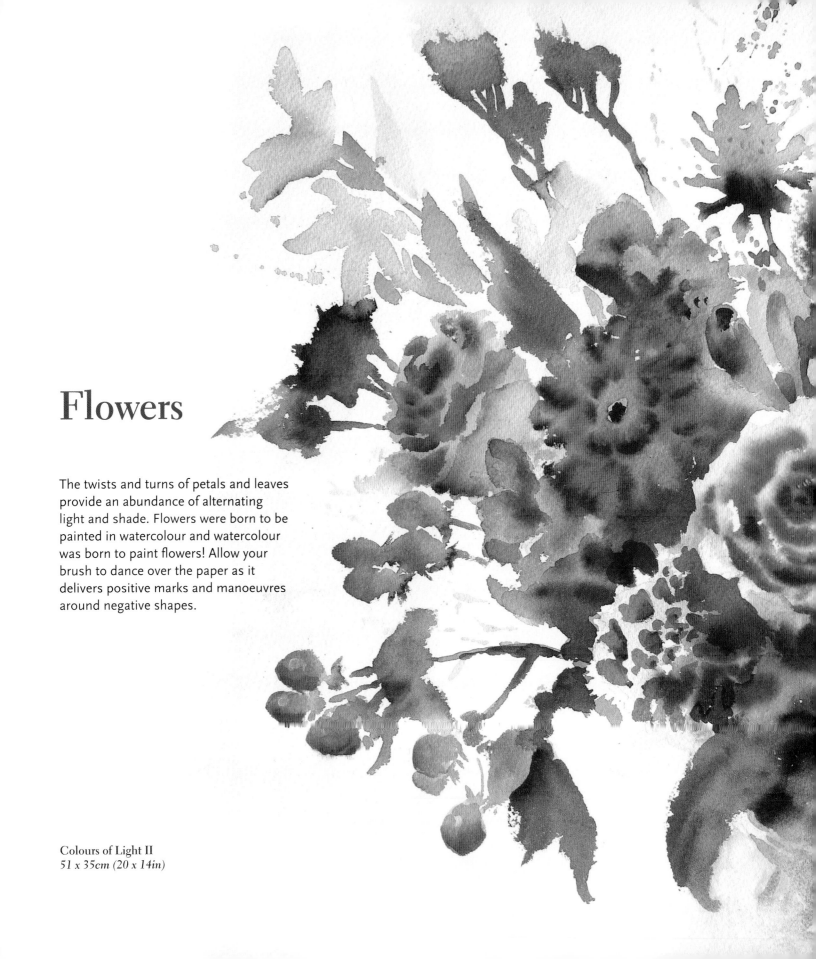

Flowers

The twists and turns of petals and leaves provide an abundance of alternating light and shade. Flowers were born to be painted in watercolour and watercolour was born to paint flowers! Allow your brush to dance over the paper as it delivers positive marks and manoeuvres around negative shapes.

Colours of Light II
51 x 35cm (20 x 14in)

Aerial Views

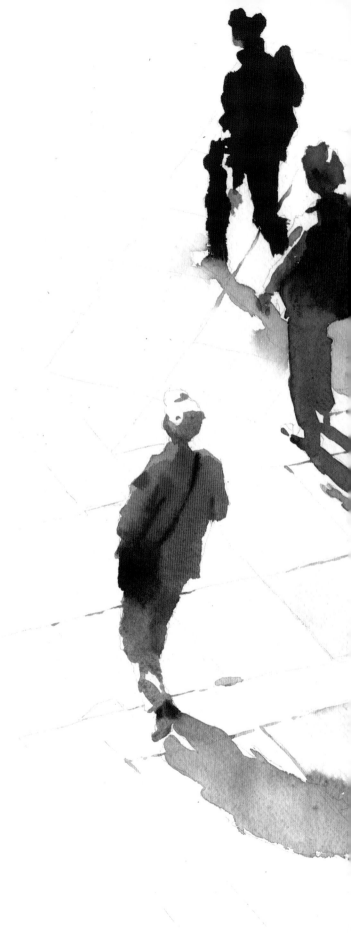

The fun of aerial views is that there is no horizon, so the abstract pattern of the composition on the paper is more obvious. These bird's eye views are also striking because unless you live in a high-rise building they are unusual. I am particularly intrigued by aerial views of busy places, with people weaving in and out of each other, unaware that they are being watched from above, but other subjects can be viewed in this way too, provided that you can find the right vantage point.

Abstract pattern

When seen from above, figures become distorted so pattern and ambiguity become easy to register.

Positive and negative shape

The shadow and the figure are one; they belong together. Groups of figures merge and shadows join up with other shadows to become interesting patterns of positive and negative shapes.

The Green Umbrella Leads the Way,
71 x 55cm (28 x 22in)

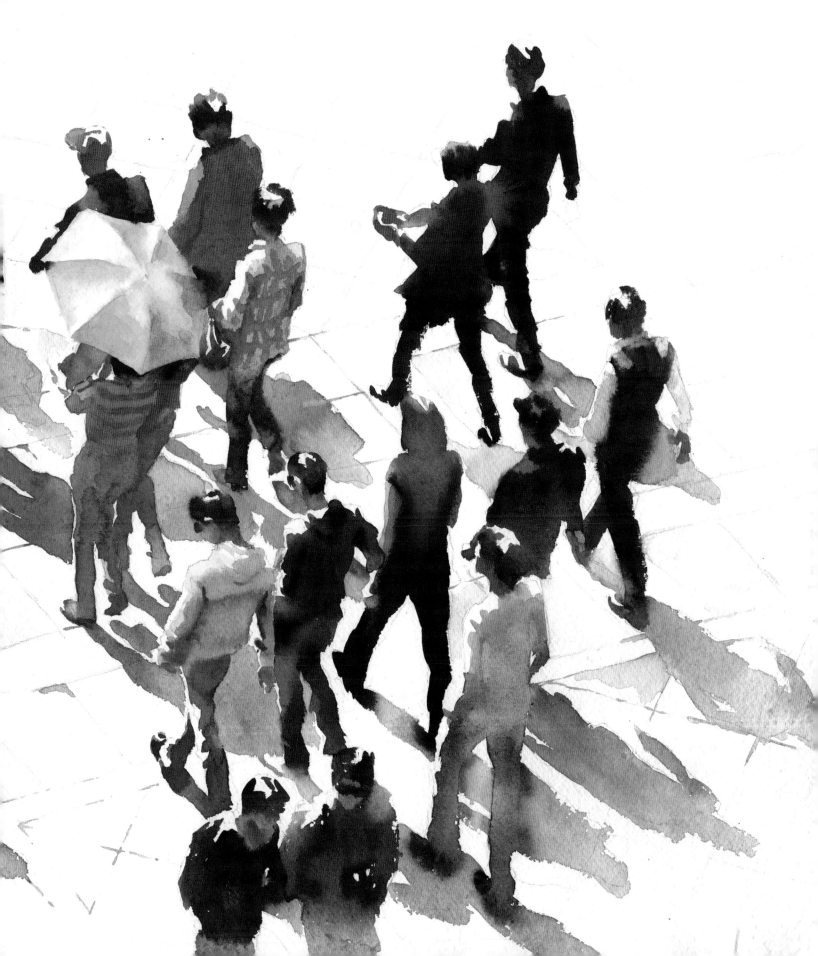

Urban Life

You may not think traffic is very attractive to paint but actually it provides the watercolourist with wonderful shiny top lights on the roofs of vehicles and delicious deep darks in the undercarriage, not to mention the delightful light and dark exchange underneath, where a rectangle of light is visible between the tyres and the shadow cast on the road.

Figures in the city

Urban scenes are enlivened by figures. If you are working from life on a scene like this tram stop, make the figure sketches on a separate page so you can add them in when the event has passed. Take note of the lighting: the tram is lit while the tram stop is in shadow. Opaque white is useful for white shirts in shadow and light red works for faces and limbs.

Riding the San Francisco Tram,
20 x 38cm (8 x 15in)

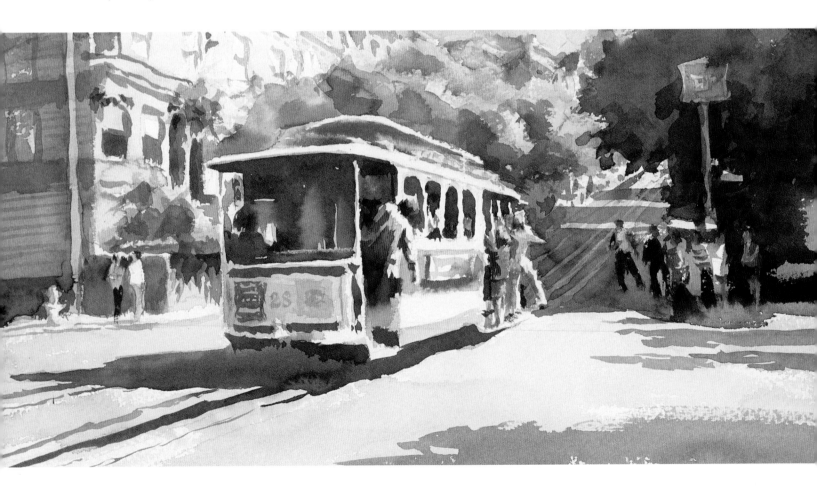

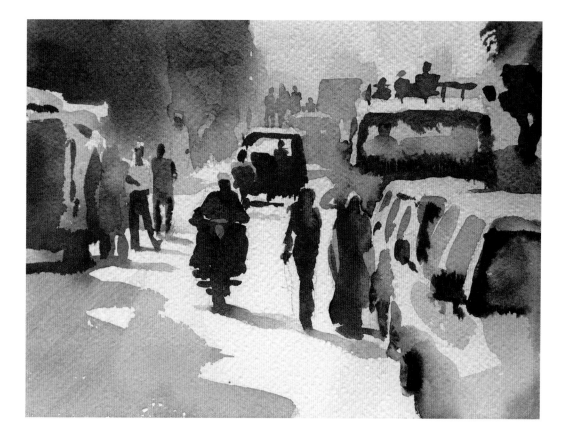

Pushkar, India,
18 x 28cm (7 x 11in)
The tumble of busy streets, especially in India, means you have to make selections as to what to include in a painting. Remember, it is the main pattern that counts – nothing you see will be the same in a second so you are in charge of your composition. For me, it is the flashes of light on top of the vehicles and the figures criss-crossing the dark and light tones, setting up a perfect opportunity for playing lights against darks and darks against lights.

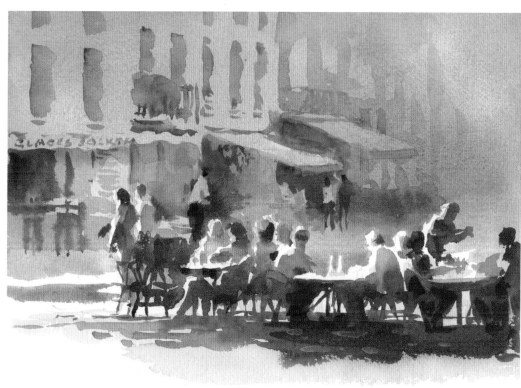

Alfresco II
25 x 35cm (10 x 14in)
Paintings of sunlit cafés in European cities are popular subjects for exploring light and shade. But these can be complex and confusing compositions unless you synthesize the myriad tonal exchanges into the main patterns of light and shade and choose which details to support and which to neglect. Café tables offer lit flat tops and lively patterns of chair legs underneath.

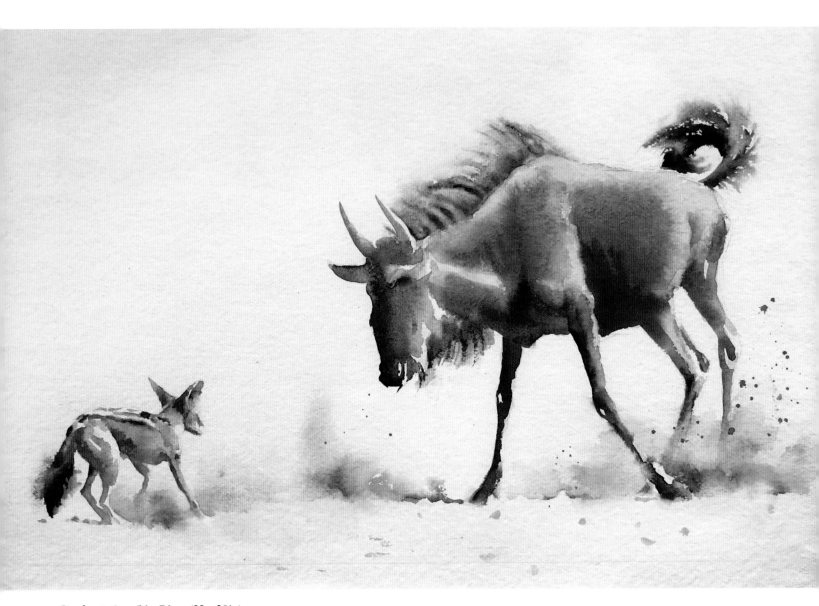

Confrontation, 56 x 76cm (22 x 30*in*)

And Finally

Bring it all together to create engaging paintings

In watercolour, we take blank paper and fashion something new that did not previously exist. In doing so, we set in motion an imagined result but allow the pigment particles to perform the magic that creates the reality – the newly created painting. We are mini-creators, enjoying in our craft a glimpse of the wonders of cosmic creation. For me, this makes painting in watercolour an amazing privilege and an awesome journey.

'Painting is more than the scum of its pots.'

Ad Reinhardt

The appearance of the watercolour on the paper is more important than its likeness to the subject. 'Lifeness', not likeness, should be the aim of the painting – however well you paint the sun or an apple, it can neither warm nor feed you. A painting is not pretending to be something, it is something: something other than what it represents. Freed from the obligation to make a likeness, the painter can create something new that did not exist before: a new lifeness!

You have seen in this book that, for the representative painter, light and shade take precedence over colour. Hopefully, I have enabled you to read the world with artists' eyes, to see the patterns of relative tone, grasp the essential values and eschew unnecessary distractions. Keep the particles of paint happy, learn their personalities, allow them some freedom and you will enjoy an exciting and wonderful journey and create meaningful and worthwhile watercolours along the way.

Bon voyage!

Beach Girl,
18 x 25cm (7 x 10in)
Patterns created by sunshine and shadow have always delighted me – the way shade obscures detail and light bleaches colour never cease to amaze me.

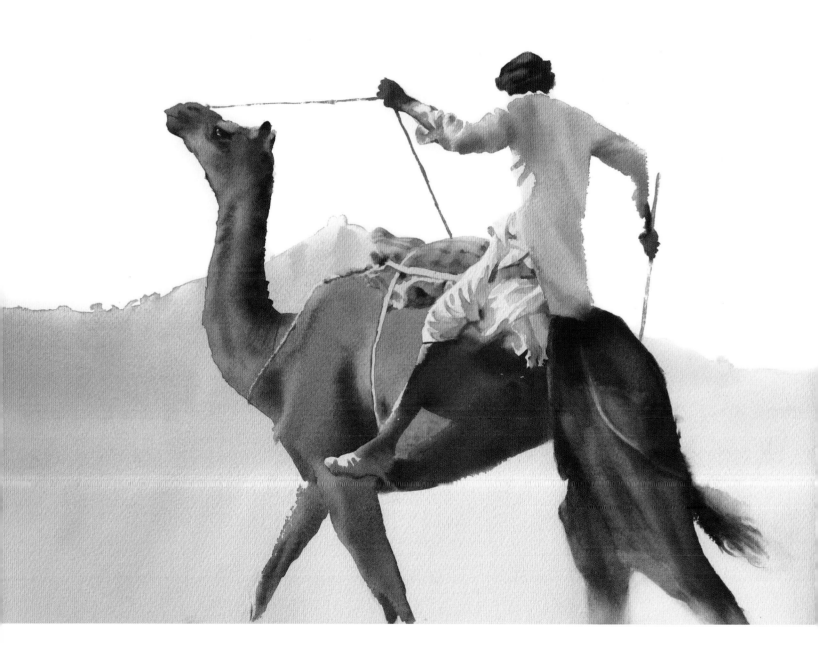

Crossing the Desert, 56 x 76cm (22 x 30in)
The simple setting, the strong shape of the camel and rider, the patterns of light fashioned by the folds in the chemise, and the strong shadow cast by the man's leg, were the elements that excited me to paint this watercolour, a fitting painting to set you off on your own thrilling journey.

Index

References to illustrations are in *italics*.

aerial views 136–7
ambiguity 48, 95, 97, 100, 103, 105, 122–3, 127
angles 20–1
architecture 126
assignments
 atmosphere 118–19
 composition balance 92–3
 lost-and-found 104–5
 masking 76–7
 patterns 50–1
 simplification 64–5
 tone 26–7
 value 36–7
atmosphere 107–11, *112*, 113, 117, 118–19

backlight 67, 70, 76, 110
backruns 87, 91, 97
balance 92–3
blacks 83, 84, 85
blues 14, 81, 82, 83, 117
blur 100, 103, 104–5, 123, 132–3
boundaries 95
brightness 86
browns 83
brushstrokes 32, 98, 99

cast shadows 47
cities 138, *139*
clothing 124, 129
colour
 atmosphere 117, 118–19
 fabric 125, 129
 hue and tone 14
 opposite colours 33, 83
 overmixing 80
 primary 81
 warm versus cool 54, 82
composition
 balance 92–3
 contrast 48
 light angles 20–1, 25
 patterns 121, 136
 planning 24, 42
 ratios 49, 65

research assignment 50–1
 shadows 47
contours 62–3, 132–3
contrast 19, 23, 48, 49, 54, 56, 62–3, 70
contre jour 18, *19*, 21
counterchange 62–3, 93
creativity 10, 49, 141

definition 48, 102, 105, 127
depth 9, 15, 44
dimensions 44, 45, 58
distance 9, 15, 44, 45, 54–5
dropping in 75
dust 113, 123

entertainment 54

fabric 124, 129
figures 128–9, 130–1, 136–7, *138*, *139*
flowers 134–5
focus 48, 49, 53, 100, 104–5
form
 contours 62–3, 132–3
 dimensions 44, *45*, 58
 highlights 70
 tonal value 42

granulation 116, *118*, *119*
greens 82
greys 83

haze 113
highlights 67, 68–71, 76–7, 102
Homer, Winslow 49
hues
 darkening 82–4
 definition 14
 primary 81
 tints 86
 value range 33, 36–7, 129

illumination 109, 110
illusion 16
imitation 41, 43
intensity 86

layering 84

life painting 43
'lifeness' 142
lifting-off technique 56, **57**, 67, 75
light angles 49, 58, 64–5, 126, 130
light conservation 67, 72–3
light intensity 19
light retrieval 74–5
light source 18–21, 60, 64
light wavelengths 13, 80
lost and found 95, 96–8, 104–5, *118*

masking 56, 67, 72, 76–7
mid-tones 88
mist 113, *114–15*
mistakes 10
monochrome 22, 36, 90, 93
mood 117 *see also* atmosphere
movement 48, 96, 97, 100, 122–3, **132–3**

negative shapes 68, 70, 72, 98, 129, 135, 136

opaque colours 56, 74, 80, 81, 86, 113
oranges 14, 32
overcast light 19, 43

paint consistency 84, 87
palettes 84, 87
paper
 buckling 103
 representing light 8, 24, 32, 34, 35, 43, 67–9
patterns
 architecture 126
 composition 42, 121, 136
 depth 15, 16
 fabric 124
 monochrome 90
 painting 41
 repetition 128–9
 representational painting 16
 research assignment 50–1
perspective 93

photographic references 43, 90
pigments 80, 86, 95, 116
plein-air 18, 43
portraits 130–1
profiles 131
proximity shadows 47

radiance 86
ratios 49, 65
reds 14, 32, 81, 82, 117
reflected light 59, 60, 61, 90, 91
relativity 56
repetition 128, 129
representational painting 15, 16, 142

salt crystals 72
scratching off 74
shades (colour) 14
shadows 17, 43, 46–7, 60, 90, 103, 110–11, 136
sight
 depth 15
 squinting 23
 tone 9
 value 23
simplification 64–5
sketching 24, 64, 92
sponging off 75
sunlight 19, 43

texture 70, 71, 72, 73, 132–3
thought patterns 10
time of day 43
timeframes 18
tints 14, 85
tonal value
 assessment **10**, 22, 23, 56, 60, 88
 colour 14, 79, 81
 definition 9
 depth 15, 16
 form 42, 58, 62–3
 paint consistency 87
 research assignment 64–5
 sketching 24, 64, 92
tone
 definition 9, 14

dimensions 44, 45
distance 54–5
linking 46
mid-tones 88
range 22
relativity 26, 56–7, 64–5, 79, 88, 126
research assignment 26–7
traffic 138
transition 44, 45, 50, 88, 132
transparency 31, 34, 80, 81, 84, 86, 109

value
 assessment 23
 colour 14, 79, 81
 definition 9
 depth 15, 16, 54
 dimensions 44, 45
 hue 33
 relativity 56–7, 64–5, 79, 126
 research assignment 36–7, 88
variety 54
violets 14

washes 32, 34, 56, 75, 86, 87, 90, 109–11
water, amount to use 84, 87, 103
water, light sparkling 67, 70
wax resist 67, 73
wet-into-wet
 atmosphere 108
 backruns 87, 91, 97
 blacks 84
 lost-and-found 95, 96, 98
 movement 123
 planning 34, 101
 reflected light 60, 61
 shadows 90, 92
 texture 71
 timing 97
 transitions 45, 132
wet-on-dry 95, 102
whites 32, 43, 74, 113
wildlife 132–3

yellows 14, 33, 81